A Pack of Dogs

A Pack of Dogs
An Anthology

———

COMPILED BY
Lucy Smith

ILLUSTRATIONS BY
Christopher Brown

MERRELL
LONDON · NEW YORK

First published 2010 by

Merrell Publishers Limited
81 Southwark Street
London SE1 0HX

merrellpublishers.com

British Library Cataloguing-in-Publication data:
A pack of dogs : an anthology.
1. Dogs – Literary collections.
I. Smith, Lucy. II. Brown, Christopher.
820.8'03629772-dc22

ISBN 978-1-8589-4531-6

Produced by Merrell Publishers Limited
Designed by Jonny Burch
Project-managed by Rosanna Lewis

Printed and bound in China

LUCY SMITH has written a number of non-fiction
books for young adults and children. She has a
lifelong love of all animals, especially dogs.

CHRISTOPHER BROWN studied at the Royal
College of Art and later worked for the artist
Edward Bawden. He has exhibited his prints
around the United Kingdom.

Introduction

'Dog' is a short word long on sense. How to do justice to dogs? In creating this anthology, I had certain criteria in mind. I wanted to touch into life the dog's variety – for it exists in so many shapes, sizes and colours; and its versatility – our lives intermingle with those of dogs in a multitude of intriguing, often unexpected, ways; I wanted to look at the bond between dogs and people from both points of view; and to highlight the different ways in which we apprehend dogs – usually, but not always, as forces for good and as delightful companions. I also wanted to find pieces that conveyed the wonderful spectrum of moods and feelings that dogs can suggest (when used metaphorically in literature) or, in reality, bring into our lives: their sympathy in times of trouble, and their tremendous *joie de vivre*.

It has been a hugely enjoyable and stimulating task, to bring together all these authors – most, but not all, writers by profession – in a collective contemplation of and cogitation about what a dog is, how it might feel, what it means to us and why. Writers of course make ideal companions for dogs, often being based at home, and – if they are to get any serious work done – having to stay in the study for hours at a time. This affords them and their dogs ample opportunity to observe each other minutely, and it is this osmotic connection that Virginia Woolf so astutely and wittily describes in *Flush*, her famous 'biography' of Elizabeth Barrett Browning's cocker spaniel (see pp. 36–39). Perhaps no other writer has captured with quite such immediacy, idiosyncrasy and sustained, brilliant fluency what it might mean to be a dog, with all that that entails; nor imagined quite so intensely, and with such subtlety and insight, what is passing between owner and dog, and what that bond might mean to each. The intensity that Woolf brings to every incident exactly suits the dog's consciousness, and anyone who has ever lived with a cocker (I confess a bias here) will recognize the truth of the portrait. This quickened response to every moment is surely one reason we so enjoy the company of dogs: they nip at the filament of life with unflagging alertness and enthusiasm.

A dog is a gift to a writer also because dogs' speechlessness is an element of pathos that can be powerfully deployed in literature. Dogs' inability to articulate what they have seen and experienced of human life, even though they live so intimately with us and seem so attuned to our way of being, provides an immediately dramatic quality. Alan Bennett's *The Outside Dog* (see pp. 103–11) exploits this to the full. He manages at once to create a realistic portrayal of the dog and its relationship with its owners, while implying all the time that it possesses some other, subconscious knowledge, as if it is the unspoken conscience of the couple caught up in their terrible, and terrifying, situation. The way in which the dog is always there, in every scene, and inveigles its way from outside into the bedroom, mirrors the way in which Marjory gradually allows her knowledge that her husband is indeed what he is to rise to her conscious mind; the fact that neither she nor the dog can speak of what they know is extremely poignant, and creates riveting dramatic tension.

Dogs' speechlessness has also of course led thousands of people to speculate about what they are thinking and feeling, and to be tempted to attribute human qualities to them. This temptation is all too understandable when one looks into the eyes of a dog that one trusts, and that, in its turn, trusts and knows one well. There is a sense of being in the presence of a noble, soulful sensibility, all the more affecting and impressive for being embodied in a form so unlike our own. The mystery of what the dog experiences, and why we – on the face of it such different creatures from dogs – feel such a strong connection to its 'soul', partly explains our enduring fascination with dogs.

Although I am not a fan of sentimentalizing our relationship with dogs – I'm with Katharine Rogers (see pp. 130–32) on this one, in that I feel it does dogs a disservice – it is true that, through our very real love for them, and theirs for us, many of us come to depend on their company as much as they do on ours. Although it has been claimed that it is humanity's awareness of its own mortality that distinguishes us from other animals, surely it is also our sense of our loneliness in the universe that characterizes us as human, and this must have

played a part in our developing such a strong bond with dogs. We gain comfort simply from the notion of companionship with them: almost as much comfort, in fact, as from the actual companionship itself, which, as all dog owners know, is fraught with inconveniences.

Dogs also get everywhere and can pass more or less unremarked. For these reasons they have often been used in pivotal roles in stories. I have tried to suggest through these extracts all the places a dog might go or lead us – literally, as in Peter Ackroyd's evocation of the strays of London, running through its streets and fields; emotionally, as in J.M. Coetzee's moving and sobering delineation of his protagonist's awakening, through his work with dogs, into compassion, or – more cheerily – John Galsworthy's charming description of Aunt Juley's happy revival through her chance encounter with Pom; or into the darkest places in the land and in the psyche, as in Conan Doyle's spellbinding account of the terrifying hound of the Baskervilles. Dogs are unpretentious levellers, content to accompany paupers or princes, as Keith Thomas pertinently points out in his excellent portrayal of King Charles II crooning over his spaniels at the council table.

It is not only by inhabiting our spaces that dogs affect us; they also live with us through time. As Jeffrey Masson (see pp. 41–44) points out, 'the dog opens a window into the delight of the moment. ... [In its company] we too enter a kind of timeless realm, where the future becomes irrelevant'. But as Dodie Smith eloquently shows in *The Hundred and One Dalmatians* (see pp. 64–68), we partly love dogs, too, because they connect us to our pasts. A dog may be cherished as the last remaining link with someone we have lost whom the dog also loved, and, like us, misses. And a dog's fidelity and steady, tender trust can provide us with a sustaining sense of constancy in an otherwise uncertain life.

Dogs – as we see all too often – do not necessarily benefit from our desire to own and manage (or mismanage) them. We are all probably familiar with the man and his 'power dog', the owner who makes a show of dominating and bullying the animal, believing (mistakenly) that he thereby vaunts and aggrandizes his status. But, as several of these extracts reveal, one particularly intriguing and entirely irrational aspect of our relationship with dogs is the fact that so frequently they

elude our control – completely. We expend energy and thought on training them, but anyone who lives with a dog knows how quickly, intuitively and unself-consciously *it* trains *us*. Try as we may, we will never fully understand why this happens, and we give ourselves away as we strive to comprehend dogs' role in our life, and the continued impulse we have to connect with them. Yet this is surely one of the most endearing things about it: we keep dogs as much for their capacity to be simply their doggy selves, and for what they elicit from and discover to us about ourselves, as for what we may get from them.

Christopher Brown's illustrations were a vital part of the inspiration for this book. With what wonderful and beguiling economy he brings dogs to life at the stroke of a knife; his dogs are wistful, curious, busy about their business, antic, up to all sorts of tricks – some likely, others more fantastical – but always somehow truly dog-like in character. The work speaks for itself, and to analyse it would be to spoil it and its apparent (though expertly crafted) spontaneity; but suffice to say that its comedic energy and fluent dash are completely true to the best of what we love about dogs. This book was very much conceived in collaboration with him and to reflect the eloquent, delightful nature of the dogs he creates.

It was easy to find any number of writings about dogs: they seemed to leap up at me eagerly from all quarters. More difficult were the decisions about what not to include: the dogs for which I could not find a home here. Ultimately, the criteria were the quality of the writing – I hope that every extract will not only entertain or compel, but also ring true – and how the extracts could play off one another. The book, although it includes many pedigrees, may be thought of as an engaging mongrel: not without its faults, of course, but uniting, too, all that is best and brightest about the dog, surely of all creatures the one that deserves to be held most dear.

LUCY SMITH

Dog Profiles

KAY WHITE *and* J.M. EVANS, *respectively a dog breeder
and a veterinary surgeon with an international reputation, have
written several successful books on rearing and training dogs, and bring
to their work a huge amount of practical experience. This extract, from
their* How to Have a Well-Mannered Dog *(1981), although essentially
factual, also manages succinctly to epitomize the nature of the dog in
a way that conveys exactly why so many people find dogs appealing.
There is something unexpectedly charming, too, in the last entry
on this list, which perfectly captures the dog's point of view.*

THINGS DOGS DO BETTER THAN HUMANS

1. Hear sounds at long distance and far higher range.

2. Acquire information by scent trails.

3. They have greater agility than most people, they run faster
and climb better; they twist, turn and dodge better, and they
can get through surprisingly small holes.

4. Dogs can take a lot of exercise in a short time.

5. They keep a very persistent and constant watch on happenings
on their territory and the body movements of their owners.

THINGS DOGS CANNOT DO

1. Think in advance.

2. Interpret *words*; they listen to *sounds* and intonation.

3. Recognition of unfamiliar shapes at long
distance; identify by colour.

4. Dogs are not good at deception, treachery, or falsehood.

THE DOG IS SUSCEPTIBLE TO:

1. Pack leadership.

2. Habit, routine.

3. Rewards of many types, especially food and praise.

4. Magic, thrown objects and deterrents which appear to come from outer space.

Kay White and J.M. Evans
How to Have a Well-Mannered Dog
ELLIOT RIGHT WAY BOOKS
1981

The Truth About Dogs

*The natural world has been a central element
in both the personal and the working life of author and historian
STEPHEN BUDIANSKY. He was for some time the Washington editor of the
journal* Nature, *and four of his books focus on aspects of animal behaviour.
Certainly his take on dogs, in this extract, is an unfooled, though affectionate,
one. Budiansky has mentioned that his interest in animals may stem from
the fact that as a child he wasn't allowed to keep any pets, not even a frog.
Much of his writing about animals insists on the idea that we should
understand and appreciate them on their own terms,
rather than projecting ourselves and our
feelings on to them.*

I f some advertiser or political consultant could figure out just what it is in human nature that makes us so ready to believe that dogs are loyal, trustworthy, selfless, loving, courageous, noble, and obedient, he could retire to his own island in the Caribbean in about a week with what he'd make peddling that secret.

Dogs belong to that elite group of con artists at the very pinnacle of their profession, the ones who pick our pockets clean and leave us smiling about it. Dogs take from the rich, they take from the poor, and they keep it all. They lie on top of the air-conditioning vent in the summer, they curl up in front of the fireplace in winter, they commit outrages upon our property too varied and unspeakable to name. They decide when we may go to bed at night and when we must rise in the morning, where we may go on vacation and for how long, whom we may invite over to dinner, and how we should decorate our living rooms. They steal the very bread from our plates. ... If we had a roommate who behaved like this, we'd be calling a lawyer, or the police.

I don't generally consider myself a pushover, and it's been years and years since I believed that any dog of mine was as faithful as, well, a bird dog, never mind as kind as Santa Claus. But not long ago, as a result of a sequence of events that I cannot fully reconstruct, much less comprehend, I found myself believing it

perfectly normal behavior on my part to carry a sixty-five-pound collie dog up the stairs to my bedroom every night, and back down the stairs every morning. This went on for months. I had no choice in the matter.

Flip open any veterinary journal these days and your eye is almost certain to land on a case report of a dog that has completely taken over a household, cowing its nominal owners into submission and obedience to a routine that the dog himself has dictated

Dogs that have their owners tiptoeing around them as they lie in their favorite spots on the living room floor, owners who are terrified to move the dog's food bowl or clip a leash to the dog's collar, dogs that refuse to allow their owner to pass through a door before them, dogs that forbid boyfriends or husbands to hug, kiss, or dance with their female owners, dogs that menace their owners into petting them on command, walking them on command, feeding them on command – these are staple characters in the reports that pour in from veterinary clinics. But this is nothing new. *Cave canem*, the Latin phrase that Roman householders liked to inscribe in their mosaic floors two thousand years ago, means 'Beware of the dog.' I think it was a not entirely facetious suggestion that this might have meant beware of the dog *not* in the sense of 'don't get bitten,' but in the sense of 'Please be careful not to trip over him because he's not going to get up and move out of your way.'

Almost as common as the clinical accounts of dogs who have seized effective operational control of their households are the accounts in veterinary journals of dogs who engage in eccentric and obsessive behaviors that, were they exhibited in humans, would lead to swift institutionalization – or justifiable homicide by

anyone forced to share living quarters with the patient. Yet in dogs these behaviors are suffered and endured year after year after year: chasing imaginary objects, running in circles, consuming excrement, barking incessantly. One five-year-old Shetland sheepdog was reported to have spent two years compiling an ever-growing list of things to bark at, which eventually included:

> *Large truck passing*
> *Pots and pans banging*
> *Hair dryer turned on*
> *Person walking quickly*
> *Dog's water bowl being filled*
> *Toilet flushing*
> *Owner brushing her teeth*
> *Door of dishwasher being opened*
> *Person sneezing*
> *Leaves blowing in wind*

Frequent reports of dogs that chew up shoes, books, newspapers, bedsheets, currency, laundry, sofas, rugs, tables, wallboard, wood trim, doors, stairs, and window screens appear in the scientific literature. Perhaps even more impressive than the things we put up with are the things we are successfully conned into. Dogs feign illness with an inventiveness that rivals that of any human exhibitor of Munchausen syndrome. Having learned what makes their owners lavish attention, petting, and special treats upon them, dogs exhibit lurid symptoms that have no organic basis; documented cases of fabricated ailments in dogs include coughing, profuse nasal discharge, diarrhea, vomiting, anorexia, ear problems, lameness, muscle twitching, and paralysis. Dogs are sharpshooters. We are saps.

Stephen Budiansky
The Truth About Dogs
WEIDENFELD & NICOLSON
2001

What Kind of Dog?

*Most readers probably do not immediately associate the
American author* F. SCOTT FITZGERALD *(1896–1940) with dogs:
apart from his writing, he is more likely to be remembered for a
glamorous, high-profile if turbulent life, akin to the society he describes
in other parts of the brilliant novel* The Great Gatsby *(1925), from
which the following extract is taken. But Fitzgerald was fond of dogs: his
short story 'Shaggy's Morning' (1935) features one as protagonist; and he
also composed a song that he apparently sang at parties, with the lyrics
'Larger than a rat!/More faithful than a cat!/Dog! Dog! Dog!'*

So Tom Buchanan and his girl and I went up together to New York – or not quite together, for Mrs Wilson sat discreetly in another car. Tom deferred that much to the sensibilities of those East Eggers who might be on the train.

She had changed her dress to a brown figured muslin, which stretched tight over her rather wide hips as Tom helped her to the platform in New York. At the newsstand she bought a copy of *Town Tattle* and a moving-picture magazine, and in the station drug-store some cold cream and a small flask of perfume. Upstairs, in the solemn echoing drive she let four taxicabs drive away before she selected a new one, lavender-coloured with grey upholstery, and in this we slid out from the mass of the station into the glowing sunshine. But immediately she turned sharply from the window and, leaning forward, tapped on the front glass.

'I want to get one of those dogs,' she said earnestly. 'I want to get one for the apartment. They're nice to have – a dog.'

We backed up to a grey old man who bore an absurd resemblance to John D. Rockefeller. In a basket swung from his neck cowered a dozen very recent puppies of an indeterminate breed.

'What kind are they?' asked Mrs Wilson eagerly, as he came to the taxi-window.

'All kinds. What kind do you want, lady?'

'I'd like to get one of those police dogs; I don't suppose you got that kind?'

The man peered doubtfully into the basket, plunged in his hand and drew one up, wriggling, by the back of the neck.

'That's no police dog,' said Tom.

'No, it's not exactly a police dog,' said the man with disappointment in his voice. 'It's more of an Airedale.' He passed his hand over the brown washrag of a back. 'Look at that coat. Some coat. That's a dog that'll never bother you with catching cold.'

'I think it's cute,' said Mrs Wilson enthusiastically. 'How much is it?'

'That dog?' He looked at it admiringly. 'That dog will cost you ten dollars.'

The Airedale – undoubtedly there was an Airedale concerned in it somewhere, though its feet were startlingly white – changed hands and settled down into Mrs Wilson's lap, where she fondled the weather-proof coat with rapture.

'Is it a boy or a girl?' she asked delicately.

'That dog? That dog's a boy.'

'It's a bitch,' said Tom decisively. 'Here's your money. Go and buy ten more dogs with it.'

<div align="center">

F. Scott Fitzgerald
The Great Gatsby
PENGUIN
1950

</div>

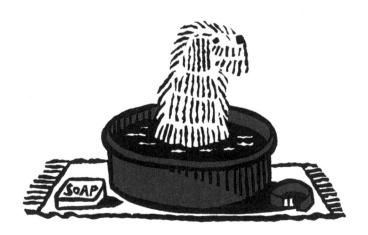

Pom

*JOHN GALSWORTHY (1867–1933), highly successful
novelist and dramatist, and winner of the Nobel Prize in
Literature 1932, was also well known for his profound love of
dogs: his depictions of them were even remarked on in the speech in
which he was awarded the Nobel. Galsworthy, who supported animal
welfare causes, created many dog characters; and he and his wife,
Ada, each produced a memoir of their pet dogs. In this extract from
On Forsyte 'Change (1930), Galsworthy evokes with sympathetic
good humour the way in which Aunt Juley's responses mirror the
dog's – 'she too panted slightly behind her veil' – as they
gradually reach an understanding.*

Dear, dear! That little white dog was running about a great deal. Was it lost? Backwards and forwards, round and round! What they called – she believed – a Pomeranian, quite a new kind of dog. And, seeing a bench, Mrs Septimus Small bent, with a little backward heave to save her 'bustle', and sat down to watch what was the matter with the white dog. The sun, flaring out between two Spring clouds, fell on her face, transfiguring the pouting puffs of flesh, which seemed trying to burst their way through the network of her veil. Her eyes, of a Forsyte grey, lingered on the dog with the greater pertinacity in that of late – owing to poor Tommy's (their cat's) disappearance, very mysterious – she suspected the sweep – there had been nothing but 'Polly' at Timothy's to lavish her affection on. This dog was draggled and dirty, as if it had been out all night, but it had a dear little pointed nose. She thought, too, that it seemed to be noticing her, and at once had a swelling-up sensation underneath her corsets. Almost as if

aware of this, the dog came sidling, and sat down on its haunches in the grass, as though trying to make up its mind about her. Aunt Juley pursed her lips in the endeavour to emit a whistle. The veil prevented this, but she held out her gloved hand. 'Come, little dog – nice little dog!' It seemed to her dear heart that the little dog sighed as it sat there, as if relieved that at last someone had taken notice of it. But it did not approach. The tip of its bushy tail quivered, however, and Aunt Juley redoubled the suavity of her voice: 'Nice little fellow – come then!'

The little dog slithered forward, humbly wagging its entire body, just out of reach. Aunt Juley saw that it had no collar. Really, its nose and eyes were sweet!

'Pom!' she said. 'Dear little Pom!'

The dog looked as if it would let her love it, and sensation increased beneath her corsets.

'Come, pretty!'

Not, of course, that he was pretty, all dirty like that; but his ears were pricked, and his eyes looked at her, bright, and rather round their corners – most intelligent! Lost – and in London! It was like that sad little book of Mrs – What *was* her name – not the authoress of *Jessica's First Prayer*? – dear, dear! Now, fancy forgetting that! The dog made a sudden advance, and curved like a C, all fluttering, was now almost within reach of her gloved fingers, at which it sniffed. Aunt Juley emitted a purring noise. Pride was filling her heart that out of all the people it *might* have taken notice of, she should be the only one. It had put out its tongue now, and was panting in the agony of indecision. Poor little thing! It clearly didn't know whether it dared try another master – not, of course, that she could possibly take it home, with all the carpets, and dear Ann so particular about everything being nice, and – Timothy! Timothy would be horrified! And yet—! Well, they couldn't prevent her stroking its little nose. And she too panted slightly behind her veil. It *was* agitating! And then, without either of them knowing how, her fingers and the nose were in contact. The dog's tail was now perfectly still; its body trembled. Aunt Juley had a sudden feeling of shame at being so formidable; and with instinct

inherited rather than acquired, for she had no knowledge of dogs, she slid one finger round an ear and scratched. It *was* to be hoped he hadn't fleas! And then! The little dog leaped on her lap. It crouched there just as it had sprung, with its bright eyes upturned to her face. A strange dog – her dress – her Sunday best! It *was* an event! The little dog stretched up, and licked her chin. Almost mechanically Aunt Juley rose. And the little dog slipped off. Really she didn't know – it took such liberties! Oh! dear – it *was* thin, fluttering round her feet! What would Mr Scoles say? Perhaps if she walked on! She turned towards home, and the dog followed her skirt at a distance of six inches. The thought that she was going to eat roast beef, Yorkshire pudding, and mincepies, was almost unbearable to Aunt Juley, seeing it gaze up as if saying: 'Some for me! Some for me!' Thoughts warred within her: must she 'shoo' and threaten it with her parasol? Or should she—? Oh! This would never do! Dogs could be *so* – she had heard? And then – the responsibility! And fleas! Timothy couldn't endure fleas! And it might not know how to behave in a house! Oh, no! She really couldn't! The little dog suddenly raised one paw. Tt, tt! Look at its little face! And a fearful boldness attacked Aunt Juley. Turning resolutely towards the Gate of the Gardens, she said in a weak voice: 'Come along, then!' And the little dog came. It was dreadful!

While she was trying to cross the Bayswater Road, two or three of those dangerous hansom cabs came dashing past – so reckless! – and in the very middle of the street a 'growler' turned round, so that she had to stand quite still. And, of course, there was 'no policeman'. The traffic was really getting beyond bounds. If only she didn't meet Timothy coming in from his constitutional, and could get a word with Smither – a capable girl – and have the little dog fed and washed before anybody saw it. And then? Perhaps it could be kept in the basement till somebody came to claim it. But how could people come to claim it if they didn't know it was there? If only there were someone to consult! Perhaps Smither would know a policeman – only she hoped not – policemen were rather dangerous for a nice-looking girl like Smither, with her colour, and such a figure, for her age. Then,

suddenly, realising that she had reached home, she was seized by panic from head to heel. There was the bell – it was not the epoch of latchkeys; and there the smell of dinner – yes, and the little dog had smelt it! It was now or never. Aunt Juley pointed her parasol at the dog and said very feebly: 'Shoo!' But it only crouched. She couldn't drive it away! And with an immense daring she rang the bell. While she stood waiting for the door to be opened, she almost enjoyed a sensation of defiance. She was doing a dreadful thing, but she didn't care! Then, the doorway yawned, and her heart sank slowly towards her high and buttoned boots.

'Oh, Smither! This poor little dog has followed me. Nothing has ever followed me before. It must be lost. And it looks so thin and dirty. What *shall* we do?'

The tail of the dog, edging into the home of that rich smell, fluttered.

'Aoh!' said Smither – she was young! 'Paw little thing! Shall I get cook to give it some scraps, Ma'am!' At the word 'scraps' the dog's eyes seemed to glow.

'Well,' said Aunt Juley, 'you do it on your own responsibility, Smither. Take it downstairs quickly.'

She stood breathless while the dog, following Smither and its nose, glided through the little hall and down the kitchen stairs. The pit-pat of its feet roused in Aunt Juley the most mingled sensations she had experienced since the death of Septimus Small.

She went up to her room, and took off her veil and bonnet. What *was* she going to say? She went downstairs without knowing. ...

John Galsworthy
On Forsyte 'Change
WILLIAM HEINEMANN LTD
1930

22

Bunch

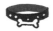

The dog mentioned in this extract by the writer JAMES DOUGLAS
*(1867–1940) was Bunch, a Sealyham terrier, a type that was originally
bred for badger hunting and was once fashionable in Hollywood among
film stars and directors (Alfred Hitchcock owned three), but that is rarely
seen now. Douglas wrote a whole book about Bunch, and was adamant
that any such 'biography' of a dog was bound to be 'a love story'.
Here, with gentle yet deceptively tenacious humour, he affirms the
importance of dogs' ability to call up in us a sense of our shared
vulnerabilities, and our irresistible urge to love.*

Before we laugh at the love lavished on dogs by the nation of lonely women
we should try to understand the hidden forces at work in each woman's
heart. A fat old woman waddling behind a fat old dog is a figure of
comedy, but she is also a figure of tragedy.

She looks ludicrous and her dog looks ludicrous, but the relation between
them is not ludicrous, for no kind of love is ludicrous when it is probed to its
depths, although all love is ludicrous if it is seen only on the surface.

When a lonely woman loves a dog she is trying to keep her soul alive. Without
some sort of love the soul is dead, for love is its way of breathing. We do not know
why we need love in order to preserve the sense of being alive. But we need it as our
blood needs the air supplied to it by our lungs.

If we are choking for lack of air in pneumonia we are re-enlivened by inhaling
oxygen. The oxygen vitalises the blood and keeps the heart going. It may be that
the love of a dog is like oxygen. It takes the place of human love. It keeps the
heart going.

It is certain that many human beings fail to fulfil and realise and complete
themselves by the mastery of human love. They have shut themselves out from
it or they have been shut out. Whether their exile is voluntary or involuntary
does not matter. This life is not integrated and unified. It has asked for unity
and has not got it.

A human life without love is in a state of asphyxiation. It is gasping for breath. I suspect that the majority of human beings go through their existence in this condition. They suffer permanently from atrophy of the affections. They lack the power to love and to be loved. They do not know that they are dying till they are dead.

It is no exaggeration to say that when a woman has nobody to love her she goes to the dogs, and the sooner she goes to the dogs the better, for if she cannot find a human creature to love or to be loved by, a dog is the next best thing, because we have humanised dogs so successfully that we are accustomed to say a dog is 'almost human'.

When I say that man has humanised the dog I do not mean only that he has tamed him, domesticated him, and taught him to perform tricks. I mean that he has discovered the soul of the dog and mingled his own soul with it. The nature of the human soul is an unfathomable and indefinable mystery. There are some who deny its existence. They say that man is a machine.

But a machine is incapable of love. I hold that the will and the power to love are a proof of the existence of the soul. We do not love with the reason, with the mind, with the brain. We love with the immortal and indestructible essence of our being, with that part of us which is above our mechanism and outside it and separate from it.

Now a dog possesses this will and power to love as really as we possess it. As I watch Bunch dogging the footsteps of Eva Alexandra, following her wherever she goes, gazing at her in dumb adoration while she is reading or sewing, I recognize the pure quality of love.

James Douglas
The Bunch Book
EYRE & SPOTTISWOODE
1932

A Dog in Love

The titles of some of MERRILL MARKOE'*s books – for example,*
The Day My Dogs Turned into Guys *(1999) – give a clue as to her*
humorous approach to our relations with dogs. Markoe (born 1952) has
also been involved in the American television programme Who Gets the
Dog?, *in which shelter dogs try out possible new homes before embarking*
on a new life. In this shrewdly imagined dialogue, a shih-tzu (otherwise
known as the 'Chrysanthemum dog') and the author 'discuss', among
other things, a bedroom slipper. It's interesting to note that the baby
Pekinese featured in the extract from Katherine Mansfield's letter
(see p. 51) has also adopted a slipper as a companion.

Everyone remembers their first love. It is a very special and yet in some ways kind of frightening time – all those new and powerful feelings. Which is why, when I first observed my smallest dog, Winky, in the throes of a continuous passionate entanglement with my dog-shaped bedroom slipper (who among us can claim to have chosen wisely that first, heady time?), I felt some kind of a parental counseling session was in order. So I lifted him up from where he was stationed in the kitchen doing what he usually is doing – moving slowly from one side of the room, to the other, licking the floor – and sat him down on the couch with me for a little chat.

Me: Winky, Winky, oh Winky. ...
Winky: Yes?
Me: You are getting to be a 'big boy' now, not big in physical stature, because genetically you're some kind of a Shih Tzu deal, but in the biggest sense of the word, by which I mean –
W: What's your point exactly? I'd like to get back to licking the floor.

Me: Well, lately I couldn't help but notice that you are having your first intimate relationship, which to you probably feels very intense, very serious. ... Please stop licking the couch like that. You're making saliva spots.

W: There are cheese molecules over by the back cushions.

Me: My point is that when someone, in this case you, has very strong positive feelings like you seem to be having lately for that shoe of mine, it's an emotion we call 'love'. Which is why I say, for example, I 'love' you.

W: Is it time for dinner yet?

Me: No, it's 9:00 in the morning.

W: And what time is dinner?

Me: About 5:00, 5:30. About eight hours from now.

W: EIGHT HOURS??? You're joking.

Me: Forget about that for just a moment. I want to talk to you about this very special time in your life because there are certain dangers, certain pitfalls that perhaps I can help you avoid.

W: Eight hours? Isn't that cruel? If I called the Humane Society, wouldn't they threaten to take me away?

Me: According to veterinary charts and the American Kennel Club, you are just about double your appropriate weight.

W: Oh, but you're perfect. You open the refrigerator door about sixty times a day. You're *always* eating.

Me: Okay, okay. Listen to me for a minute.

W: That's seven minutes to me.

Me: Love can be a very powerful experience. You may find yourself awash in feelings you've never had. When I was a girl of about fourteen, though now that I think back, perhaps the most intense first love hit when I was in my twenties ...

W: You can't compare that situation to mine. Your shoe and I have an incredible chemistry.

Me: That's exactly my point. The first time it hits you, you don't understand that chemistry and love are not exactly the same thing.

W: You just don't like to *share* anything, do you? Just like with the food portions.

Me: I don't like to share? You guys share *everything* with me. Every room in my house, every piece of furniture.

W: And this is just the way you were acting when Lewis was dating the couch. Suddenly the battle lines were drawn.

Me: This isn't about battle lines. Lewis totally wrecked that couch. I was concerned that Lewis was a batterer. I am pleased to see at least you are far gentler with my shoe.

W: You can't compare Lewis and the couch to me and the shoe. Two totally different kinds of relationships.

Me: You're the one that made the comparison. The point I wanted to make is that, as with Lewis and the couch, these things don't always end happily. Lewis destroyed that couch, I had to have it hauled away. And that's the way it is with love. A lot of times one party gets hurt.

W: Well, I knew he was playing with fire. How stupid do you have to be to get sexually involved with a *couch*???

Me: Anyway, I just wanted to caution you to go more slowly. Don't rush things. Take your time. If there's anything I've learned in life it's that there's no real good side to romantic obsession.

W: Eight hours *must* be up by now. Let's go get something to eat.

Merrill Markoe
Merrill Markoe's Guide to Love, extracted in *Dog People*
WORKMAN PUBLISHING
1995

Train Your Dog

In the 1950s and 1960s CECIL WIMHURST *published many
books on dog breeds and training. In this extract he succinctly
and unpompously describes the key factors involved in achieving a
well-trained dog. It sounds simple, but it is astonishing how often the
fundamental principles and facts about dogs are completely overlooked
or misunderstood when people try to train them. Like E.H. Richardson
(see pp. 97–100), another outstanding trainer, Wimhurst highlights
the need to work with rather than against the dog's natural instincts,
and the daunting but unavoidable – and, as he acknowledges, often
exasperating – fact that it is the owner, not the dog, who must
take responsibility if training is going to work.*

I t is true that some breeds are more amenable to training than others, and that individual dogs vary in intelligence, but the chief difference is that the experienced trainer has the know-how while the unskilled novice trains on hit-and-miss methods which tend to confuse rather than teach the dog. All dogs, at any age, can be trained provided the right principles are followed.

All training is based on making use of the animal's natural instincts. The simplest example is in making a dog come at the owner's call or whistle, thus exploiting the instinctive longing of the dog for human companionship. In tracking, the instinct of the dog in searching for food is adapted to the human needs of his handler. The dog, by constant repetition, is taught to perform a certain action until a habit is formed and the word of command is followed by the action. ...

The trainer must remember that dogs differ in temperament just as much as humans. There are quick dogs, phlegmatic dogs, clever dogs and those not so clever – there are also dogs who couldn't care less, and these are responsible for many trainers growing old before their time. Get to know your dog and vary the tempo of your training accordingly. ...

So much for the dogs, and now let us consider the more important person of the partnership – the trainer. There are very few bad dogs but there are numbers of bad trainers who blame failures on their dogs when the blame is really faulty teaching. If the lesson has gone awry, the trainer should ask himself if he was impatient, too harsh or too lenient with the dog; or if he was trying to teach the animal something for which he was not prepared by previous lessons. The chief attributes of a trainer are unlimited patience and the strength to keep his temper when he feels that there is nothing else to do but hit the dog over the head with the sharp end of a pick-axe, bury the body, and take up rabbits instead. We have all felt like that at times and there can be no doubt that our dogs dwell lovingly on the thought of burying their teeth in our shins and calling it a day.

Cecil Wimhurst
Train Your Dog
FREDERICK MULLER LTD
1953

Rex

D.H. LAWRENCE (1885–1930) *is famous for his exploration*
of love relationships. Lawrence, who died tragically young of
tuberculosis, displayed a formidable energy and appreciation of the
life force in all its forms, and was a great animal-lover. He owned a dog
called Bibbles, of which he was extremely fond and about which he wrote
a long poem, describing her as 'like a little black dragon'. This extract,
from his short story 'Rex' (1921), features a fox terrier – a breed that, as we see
elsewhere (see pp. 58–59, 99 and 146), is notoriously difficult to manage. 'Love
always exposes one's incompetence', Lawrence wrote, and here, the fierce
love between children and dog only renders them incapable of training him
effectively. The prose perfectly exemplifies the focused intensity of
Lawrence's style: always on the qui vive, taking in every detail; and
worrying away, terrier-like, at the nature of the relationship
between man and dog, trying to get at and
grip the truth of it.

And his true nature, like so much else, was dual. First he was a fierce, canine little beast, a beast of rapine and blood. He longed to hunt, savagely. He lusted to set his teeth in his prey. It was no joke with him. The old canine Adam stood first in him, the dog with fangs and glaring eyes. He flew at us when we annoyed him. He flew at all intruders, particularly the postman. He was almost a peril to the neighbourhood. But not quite. Because close second in his nature stood that fatal need to love, the *besoin d'aimer* which at last makes an end of liberty. He had a terrible, terrible necessity to love, and this trammelled the native, savage hunting beast which he was. He was torn between two great impulses: the native impulse to hunt and kill, and the strange, secondary, supervening impulse to love and obey. If he had been left to my father and mother, he would have run wild and got himself shot. As it was, he loved us children with a fierce, joyous love. And we loved him.

When we came home from school we would see him standing at the end of the entry, cocking his head wistfully at the open country in front of him, and meditating whether to be off or not: a white, inquiring little figure, with green

savage freedom in front of him. A cry from a far distance from one of us, and like a bullet he hurled himself down the road, in a mad game. Seeing him coming, my sister invariably turned and fled, shrieking with delighted terror. And he would leap straight up her back, and bite her and tear her clothes. But it was only an ecstasy of savage love, and she knew it. She didn't care if he tore her pinafores. But my mother did.

My mother was maddened by him. He was a little demon. At the least provocation, he flew. You had only to sweep the floor, and he bristled and sprang at the broom. Nor would he let go. With his scruff erect and his nostrils snorting rage, he would turn up the whites of his eyes at my mother, as she wrestled at the other end of the broom. 'Leave go, sir, leave go!' She wrestled and stamped her foot, and he answered with horrid growls. In the end it was she who had to let go. Then she flew at him, and he flew at her. All the time we had him, he was within a hair's-breadth of savagely biting her. And she knew it. Yet he always kept sufficient self-control.

We children loved his temper. We would drag the bones from his mouth, and put him into such paroxysms of rage that he would twist his head right over and lay it on the ground upside-down, because he didn't know what to do with himself, the savage was so strong in him and he must fly at us. 'He'll fly at your throat one of these days,' said my father. Neither he nor my mother dared have touched Rex's bone. It was enough to see him bristle and roll the whites of his eyes when they came near. How near he must have been to driving his teeth right into us, cannot be told. He was a horrid sight snarling and crouching at us. But we only laughed and rebuked him. And he would whimper in the sheer torment of his need to attack us.

He never did hurt us. He never hurt anybody, though the neighbourhood was terrified of him. But he took to hunting. To my mother's disgust, he would bring large dead bleeding rats and lay them on the hearth-rug, and she had to take them up on a shovel. For he would not remove them. Occasionally he brought a mangled rabbit, and sometimes, alas, fragmentary poultry. We were in terror of prosecution. Once he came home bloody and feathery and rather sheepish-looking. We cleaned him and questioned him and abused him. Next day we heard of six dead ducks. Thank heaven no one had seen him.

But he was disobedient. If he saw a hen he was off, and calling would not bring him back. He was worst of all with my father, who would take him walks on

Sunday morning. My mother would not walk a yard with him. Once, walking with my father, he rushed off at some sheep in a field. My father yelled in vain. The dog was at the sheep, and meant business. My father crawled through the hedge, and was upon him in time. And now the man was in a paroxysm of rage. He dragged the little beast into the road and thrashed him with a walking stick.

'Do you know you're thrashing that dog unmercifully?' said a passerby.

'Ay, an' mean to,' shouted my father.

The curious thing was that Rex did not respect my father any the more, for the beatings he had from him. He took much more heed of us children, always.

But he let us down also. One fatal Saturday he disappeared. We hunted and called, but no Rex. We were bathed, and it was bed-time, but we would not go to bed. Instead we sat in a row in our nightdresses on the sofa, and wept without stopping. This drove our mother mad.

'Am I going to put up with it? Am I? And all for that hateful little beast of a dog! He shall go! If he's not gone now, he shall go.'

Our father came in late, looking rather queer, with his hat over his eye. But in his staccato tippled fashion he tried to be consoling.

'Never mind, my duckie, I s'll look for him in the morning.'

Sunday came – oh, such a Sunday. We cried, and didn't eat. We scoured the land, and for the first time realized how empty and wide the earth is, when you're looking for something. My father walked for many miles – all in vain. Sunday dinner, with rhubarb pudding, I remember, and an atmosphere of abject misery that was unbearable.

'Never,' said my mother, 'never shall an animal set foot in this house again, while I live. I knew what it would be! I knew.'

The day wore on, and it was the black gloom of bed-time, when we heard a scratch and an impudent little whine at the door. In trotted Rex, mud-black, disreputable, and impudent. He trotted around with *suffisance*, wagging his tail as if to say, 'Yes, I've come back. But I didn't need to. I can carry on remarkably well by myself.' Then he walked to his water, and drank noisily and ostentatiously. It was rather a slap in the eye for us.

<div style="text-align:center">

D.H. Lawrence
'Rex', from *The Mortal Coil and Other Stories*
PENGUIN
1971

</div>

Every Dog Should Own a Man

*This rueful extract by the American humorist and
author* COREY FORD *(1902–1969) cleverly reverses the dog/owner
roles, and bears out the thesis of Stephen Budiansky (see pp. 14–16), that
we are fools where our dogs are concerned – and they know it. Again,
it is the dog that has the upper hand, or paw. In focusing on all the things
a dog can make us do, Ford highlights the comic quirkiness, indeed
absurdity, of our bond with dogs. Why, for example, would we willingly
spend time rolling a ball to and fro, and retrieving it, for a dog's
entertainment? The question must give us ... pause.*

Every dog should have a man of his own. There is nothing like a well-behaved person around the house to spread the dog's blanket for him, or bring him his supper when he comes home man-tired at night.

For example, I happen to belong to an English setter who acquired me when he was about six months old and has been training me quite successfully ever since. He has taught me to shake hands with him and fetch his ball. I've learned not to tug at the leash when he takes me for a walk. I am completely house broken, and I make him a devoted companion.

The first problem a dog faces is to pick out the right man – a gay and affectionate disposition is more important than an expensive pedigree. I do not happen to be registered but my setter is just as fond of me as though I came from a long line of blue bloods. Also, since a dog is judged by the man he leads, it is a good idea to walk the man up and down a couple of times to make sure his action is free and he has springy hindquarters.

The next question is whether the dog and man should share the house together. Some dogs prefer a kennel because it is more sanitary, but my setter decided at the start that he'd move right in the house with me. I can get into any of the chairs I want except the big overstuffed chair in the living room, which is his.

Training a man takes time. Some men are a little slow to respond, but a dog who makes allowances and tries to put himself in the man's place will be rewarded

with a loyal pal. Men are apt to be high-strung and sensitive, and a dog who loses his temper will only break the man's spirit.

Punishment should be meted out sparingly – more can be accomplished by a reproachful look than by flying off the handle. My setter has never raised a paw to me, but he has cured me almost entirely of the habit of running away. When he sees me start to pack my suitcase he just lies down on the floor with his chin on his forepaws and gazes at me sadly. Usually I wind up by cancelling my train reservations.

The first thing to teach a man is to stay at heel. For this lesson the dog should hook one end of a leash to his collar and loop the other end around the man's wrist so he cannot get away. Start down the street slowly, pausing at each telephone pole until the man realises that he's under control. He may tug and yank at first, but this can be discouraged by slipping deftly between his legs and winding the leash around his ankles. If the man tries to run ahead, bracc all four feet and halt suddenly, thus jerking him flat on his back. After a few such experiences the man will follow his dog with docility. Remember, however, that all such efforts at discipline must be treated as sport, and after a man has sprawled on the sidewalk the dog should lick his face to show him it was all in fun.

Every man should learn to retrieve a rubber ball. The way my setter taught me this trick was simple. He would lie in the centre of the floor while I carried the ball

to the far side of the room and rolled it toward him, uttering the word 'Fetch!' He would watch the ball carefully as it rolled past him and under the sofa. I would then get the ball from under the sofa and roll it past him again, giving the same command, 'Fetch!'

This lesson would be repeated until the setter was asleep. After I got so I would retrieve the ball every time I said 'Fetch!' my dog substituted other articles for me to pick up, such as an old marrow bone or a piece of paper he found in the wastebasket.

The matter of physical conditioning is important. A man whose carriage is faulty, and who slouches and droops his tail, is a reflection on the dog who owns him. The best way to keep him in shape is to work him constantly and never give him a chance to relax. Racing him up and down the street at the end of a leash is a great conditioner. If he attempts to slump into an easy chair when he gets back, the dog should leap into it ahead of him and force him to sit in a straight-backed chair to improve his posture. And be sure to get him up several times a night to go out for a walk, especially if it is raining.

Equally important is diet. Certain liquids such as beer have a tendency to bloat a man, and a dog should teach him restraint by jumping up at him and spilling his drink, or tactfully knocking the glass off the table with a sweep of his tail.

Not every dog who tries to bring up a man is as successful as my setter. The answer lies in understanding. The dog must be patient and not work himself into a tantrum if his man can't learn to chase rabbits or wriggle under fences as well as the dog does. After all, as my setter says, it's hard to teach an old man new tricks.

Corey Ford

Extracted in *A Passion for Dogs: The Dogs Home Battersea*

DAVID & CHARLES PUBLISHERS PLC

1990

Flush

VIRGINIA WOOLF (1882–1941) *grew up with dogs in
her family home, and went on in adult life to keep several more,
including the golden cocker spaniel, Pinka or Pinker, given to her by
Vita Sackville-West in 1926. This dog and the spaniel that had belonged
to the poet Elizabeth Barrett Browning were the models for Flush, the canine
hero of the book from which this extract is taken. Woolf was interested in
capturing the quintessence of life, and in exploring other ways of experiencing
it. Although apparently 'only' a book about a dog,* Flush *(1933) tackles ideas
much more profound than might at first appear: for example, what is
language? What is the nature of love? Do we become more or less
ourselves through loving? Along with its intensity, however, there
is much humour in the work: here, the author casually brings
us down to brass tacks at the end, as living
with dogs tends to do.*

But the fine summer days were soon over; the autumn winds began to blow; and Miss Barrett settled down to a life of complete seclusion in her bedroom. Flush's life was also changed. His outdoor education was supplemented by that of the bedroom, and this, to a dog of Flush's temperament, was the most drastic that could have been invented. His only airings, and these were brief and perfunctory, were taken in the company of Wilson, Miss Barrett's maid. For the rest of the day he kept his station on the sofa at Miss Barrett's feet. All his natural instincts were thwarted and contradicted. When the autumn winds had blown last year in Berkshire he had run in wild scampering across the stubble; now at the sound of the ivy tapping on the pane Miss Barrett asked Wilson to see to the fastenings of the window. When the leaves of the scarlet runners and nasturtiums in the window-box yellowed and fell she drew her Indian shawl more closely round her. When the October rain lashed the window Wilson lit the fire and heaped up the coals. Autumn deepened into winter and the first fogs jaundiced the air. Wilson and Flush could scarcely grope their way to the pillar-box or to the chemist. When they came back, nothing could be seen in the room but the pale busts glimmering wanly on the tops of the wardrobes; the peasants and

the castle had vanished on the blind; blank yellow filled the pane. Flush felt that he and Miss Barrett lived alone together in a cushioned and firelit cave. The traffic droned on perpetually outside with muffled reverberations; now and again a voice went calling hoarsely, 'Old chairs and baskets to mend', down the street: sometimes there was a jangle of organ music, coming nearer and louder; going further and fading away. But none of these sounds meant freedom, or action, or exercise. The wind and the rain, the wild days of autumn and the cold days of mid-winter, all alike meant nothing to Flush except warmth and stillness; the lighting of lamps, the drawing of curtains and the poking of the fire.

At first the strain was too great to be borne. He could not help dancing round the room on a windy autumn day when the partridges were scattering over the stubble. He thought he heard guns on the breeze. He could not help running to the door with his hackles raised when a dog barked outside. And yet when Miss Barrett called him back, when she laid her hand on his collar, he could not deny that another feeling, urgent, contradictory, disagreeable – he did not know what to call it or why he obeyed it – restrained him. He lay still at her feet. To resign, to control, to suppress the most violent instincts of his nature – that was the prime lesson of the bedroom school, and it was one of such portentous difficulty that many scholars have learnt Greek with less – many battles have been won that cost their generals not half such pain. But then, Miss Barrett was the teacher. Between them, Flush felt more and more strongly, as the weeks wore on, was a bond, an uncomfortable yet thrilling tightness; so that if his pleasure was her pain, then his pleasure was pleasure no longer but three parts pain. The truth of this was proved every day. Somebody opened the door and whistled him to come. Why should he not go out? He longed for air and exercise; his limbs were cramped with lying on the sofa. He had never grown altogether used to the smell of eau-de-Cologne. But no – though the door stood open, he would not leave Miss Barrett. He hesitated half-way to the door and then went back to the sofa. 'Flushie', wrote Miss Barrett, 'is my friend – my companion – and loves me better than he loves the sunshine without.' She should not go out. She was chained to the sofa. 'A bird in a cage would have as good a story', she wrote, as she had. And Flush, to whom the whole world was free, chose to forfeit all the smells of Wimpole Street in order to lie by her side.

And yet sometimes the tie would almost break; there were vast gaps in their understanding. Sometimes they would lie and stare at each other in

blank bewilderment. Why, Miss Barrett wondered, did Flush tremble suddenly, and whimper and start and listen? She could hear nothing; she could see nothing; there was nobody in the room with them. She could not guess that Folly, her sister's little King Charles, had passed the door; or that Catiline the Cuba bloodhound had been given a mutton-bone by a footman in the basement. But Flush knew; he heard; he was ravaged by the alternate rages of lust and greed. Then with all her poet's imagination Miss Barrett could not divine what Wilson's wet umbrella meant to Flush; what memories it recalled, of forests and parrots and wild trumpeting elephants; nor did she know, when Mr Kenyon stumbled over the bell-pull, that Flush heard dark men cursing in the mountains; the cry, 'Span! Span!' rang in his ears, and it was in some muffled, ancestral rage that he bit him.

Flush was equally at a loss to account for Miss Barrett's emotions. There she would lie hour after hour passing her hand over a white page with a black stick; and her eyes would suddenly fill with tears; but why? 'Ah, my dear Mr Horne', she was writing. 'And then came the failure in my health ... and then the enforced exile to Torquay ... which gave a nightmare to my life for ever, and robbed it of more than I can speak of here; do not speak of that anywhere. *Do not speak of that*, dear Mr Horne.' But there was no sound in the room, no smell to make Miss Barrett cry. Then again Miss Barrett, still agitating her stick, burst out laughing. She had drawn 'a very neat and characteristic portrait of Flush, humorously made rather like myself', and she had written under it that it 'only fails of being an excellent substitute for mine through being more worthy than I can be counted'. What was there to laugh at in the black smudge that she held out for Flush to look at?

He could smell nothing; he could hear nothing. There was nobody in the room with them. The fact was that they could not communicate with words, and it was a fact that led undoubtedly to much misunderstanding. Yet did it not lead also to a peculiar intimacy? 'Writing', Miss Barrett once exclaimed after a morning's toil, 'writing, writing ...' After all, she may have thought, do words say everything? Can words say anything? Do not words destroy the symbol that lies beyond the reach of words? Once at least Miss Barrett seems to have found it so. She was lying, thinking; she had forgotten Flush altogether, and her thoughts were so sad that the tears fell upon the pillow. Then suddenly a hairy head was pressed against her; large, bright eyes shone in hers; and she started. Was it Flush, or was it Pan? Was she no longer an invalid in Wimpole Street, but a Greek nymph in some dim grove in Arcady? And did the bearded god himself press his lips to hers? For a moment she was transformed; she was a nymph and Flush was Pan. The sun burnt and love blazed. But suppose Flush had been able to speak – would he not have said something sensible about the potato disease in Ireland?

So, too, Flush felt strange stirrings at work within him. When he saw Miss Barrett's thin hands delicately lifting some silver box or pearl ornament from the ringed table, his own furry paws seemed to contract and he longed that they should fine themselves to ten separate fingers. When he heard her low voice syllabling innumerable sounds, he longed for the day when his own rough roar would issue like hers in the little simple sounds that had such mysterious meaning. And when he watched the same fingers for ever crossing a white page with a straight stick, he longed for the time when he too should blacken paper as she did.

And yet, had he been able to write as she did? – The question is superfluous happily, for truth compels us to say that in the year 1842–43 Miss Barrett was not a nymph but an invalid; Flush was not a poet but a red cocker spaniel; and Wimpole Street was not Arcady but Wimpole Street.

Virginia Woolf
Flush
BLACKWELL PUBLISHERS LTD
1999

Spaniels

EDWARD JESSE (1780–1868) *wrote several books on natural history, including* Anecdotes of Dogs (1846), *from which this lovely extract about spaniels is taken. The book, as its title suggests, is full of affectionate vignettes about many different breeds, and Jesse certainly brought a naturalist's eye to his appreciation of their specific qualities. This description perfectly captures the outstanding charm of these beautiful and vivacious dogs, their endless appetite for life, and their wonderful, quicksilver, sympathetic energy.*

Spaniels in cover are merry and cheerful companions, all life and animation. They hunt, they frisk about, watching the movements of their master, and are indefatigable in their exertions to find game for him. Their neat shape, their beautiful coat, their cleanly habits, their insinuating attention, incessant attendance, and faithful obedience, insure [*sic*] for them general favour. It is almost impossible, therefore, not to have the greatest attachment and affection for them, especially as few dogs evince so much sagacity, sincerity, patience, fidelity and gratitude. From the time they are thrown off in the field, as a proof of the pleasure they feel in being employed, the tail is in perpetual motion, and upon the increased vibration of which, the experienced sportsman well knows when he is getting nearer to the game.

Edward Jesse
Anecdotes of Dogs
R. Bentley
1846

Dogs Never Lie About Love

JEFFREY MASSON (born 1941) is an American author who
trained as a psychoanalyst. While writing the book from which this
extract is taken, Dogs Never Lie About Love *(1997), Masson acquired*
three dogs, to which he refers repeatedly as anecdotal evidence. Whether
or not one agrees with Masson's assessment of a dog's ability to sniff out
the truth about us, it springs from his own quest for understanding. He
is by no means the first person, nor will he be the last, to believe that dogs
by their very nature experience life in an essentially truthful way and
therefore establish honest relationships with their owners. Enid Bagnold
(see pp. 58–59) might have had something to say about that.

Humans have a tendency to immerse themselves in their own narcissistic concerns, losing awareness of the world around them. Not only pity for the self, but self-concerns of many varieties preoccupy us. Perhaps one central reason for loving dogs is that they take us away from this obsession with ourselves. When our thoughts start to go in circles, and we seem unable to break away, wondering what horrible event the future holds for us, the dog opens a window into the delight of the moment. Walking with a dog is to enter the world of the immediate. Our dog stares up into a tree, watching a squirrel – she is there and nowhere else.

'What are dogs interested in?' asked Elizabeth Marshall Thomas, who came up with the obviously correct answer: other dogs. But not just that. I have watched the faces of my three dogs freezing with intense interest; whatever the task at hand is, they bring such focused intensity to it. They turn to watch which way I will go at a fork in the road. They are so interested. It is extraordinary how much interest they can invest in the most ordinary thing. I find it entirely humbling. That concentrated, full, complete, undisturbed interest is what everybody wants from their own human companion.

Rani almost never stops wagging her tail. She seems to be pure happiness, all the time, everywhere – as long as she is outdoors. We humans are artificially confined, even though we confine ourselves. Our light is artificial, as is our food, our clothes, and much of our conversation, as well as the objects that surround us – cars, clocks, computers and washing machines. When we are out with our dogs, we are able to leave this world of artifice behind. Many people report the therapeutic effects of walking with a dog, how it is stimulating and soothing at the same time.

Later in the book I dispute the philosophical claim that dogs have no conception of time, but there is a sense in which this claim is true: dogs do not appreciate time that is set by convention; they do not divide a day up into minutes or hours, neither do they think in terms of weeks or months or years. A dog does not tremble at the thought of its own mortality; I doubt if a dog ever thinks about a time when it will no longer be alive. So when we are with a dog, we too enter a kind of timeless realm, where the future becomes irrelevant.

When I was growing up, my family habitually judged one place in comparison with another from their memory. The present, of course, could never compete with the past, especially an idealised past. I too picked up this bad habit. A close companion would often have to admonish me: 'Why do you compare one beach to another? You are here now; enjoy it for what it is.' I learn the same lesson from watching my dogs: they are never paralysed by the need to judge and to compare. They are never gloomy at the thought that this walk was not as nice as yesterday's walk, this forest not nearly as interesting as last week's forest. Each walk is new, unique, and uniquely interesting, with its own set of smells and delights. I keep looking for my dog's favourite walks, but the truth is, they have no favourite walks; only I do. They love all walks. They love walking. They love being wherever they are. The reason, and it is a great lesson, is no doubt that they are perfectly content to be who they are, without torturing themselves with alternatives: they love being dogs.

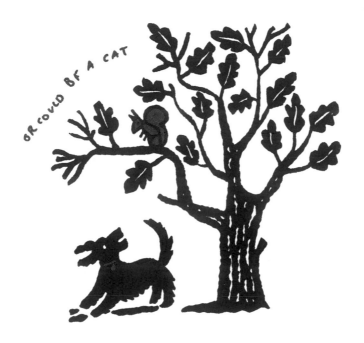

Marjorie Garber speculates that dogs allow us to fantasise about spontaneity, emotional generosity and togetherness. This is right, partly I think because dogs 'are strangers to cynicism'. Dogs are not worried about how they will be perceived by other dogs. They do not have to hide their *joie de vivre* for fear of appearing naïve, and they do not need to feign boredom when they are in fact interested for fear of appearing unsophisticated. Dogs never stand around at parties wondering what to say, or why they came, or how pitiful they might seem to more elegant or more amusing or more important guests. They do not struggle to be witty, getting right to the point, going straight for the source. Yet they manage to come away with a greater and more accurate fund of information than humans do at their parties. For the dog sex may or may not be present, in deed or thought, but information, knowledge is critical: what kind of dog am I dealing with? Who stands before me? Where have you been and what did you do there? But even more basic: who are you really?

Questers of the truth, that's who dogs are; seekers after the invisible scent of another being's authentic core.

<div style="text-align:center">

Jeffrey Masson
Dogs Never Lie About Love
JONATHAN CAPE
1997

</div>

Let the Dog Alone

EMILY BRONTË'S *short life (1818–1848) was marked early on
by the death of her mother and two elder sisters before Emily was
seven years old. It may be that these harsh losses contributed to what
by many accounts became her reclusive, strange, fierce and somewhat
alienated personality. She is reputed to have had few if any friends
outside her immediate family, and to have preferred the company of dogs
to people: she famously formed a powerful, although initially turbulent,
relationship with her mastiff-type dog, Keeper. But Brontë's attitude to
dogs was resolutely unsentimental. Dogs abound in her extraordinary
and spectacularly violent novel,* Wuthering Heights *(1847), and in this
extract provide a persistently feral, disquieting undertow – a 'long,
guttural snarl' – menacing, troubling, and unforgettable.*

Above the chimney were sundry villainous old guns, and a couple of horse-pistols: and, by way of ornament, three gaudily painted canisters disposed along its ledge. The floor was of smooth, white stone; the chairs, high-backed, primitive structures, painted green: one or two heavy black ones lurking in the shade. In an arch under the dresser, reposed a huge, liver-coloured bitch pointer, surrounded by a swarm of squealing puppies; and other dogs haunted other recesses. ...

I took a seat at the end of the hearthstone opposite that towards which my landlord advanced, and filled up an interval of silence by attempting to caress the canine mother, who had left her nursery, and was sneaking wolfishly to the back of my legs, her lip curled up, and her white teeth watering for a snatch. My caress provoked a long, guttural snarl.

'You'd better let the dog alone,' growled Mr Heathcliff in unison, checking fiercer demonstrations with a punch of his foot. 'She's not accustomed to be spoiled – not kept for a pet.' Then, striding to a side door, he shouted again, 'Joseph!'

Joseph mumbled indistinctly in the depths of the cellar, but gave no intimation of ascending; so his master dived down to him, leaving me *vis-à-vis* the ruffianly bitch and a pair of grim shaggy sheep-dogs, who shared with her a jealous guardianship over all my movements. Not anxious to come in contact with their fangs, I sat still; but, imagining they would scarcely understand tacit insults, I unfortunately indulged in winking and making faces at the trio, and some turn of my physiognomy so irritated madam, that she suddenly broke into a fury and leapt on my knees. I flung her back, and hastened to interpose the table between us. This proceeding roused the whole hive: half a dozen four-footed fiends, of various sizes and ages, issued from hidden dens to the common centre. I felt my heels and coat-laps peculiar subjects of assault; and parrying off the larger combatants as effectually as I could with a poker, I was constrained to demand, aloud, assistance from some of the household in re-establishing peace.

Mr Heathcliff and his man climbed the cellar steps with vexatious phlegm: I don't think they moved one second faster than usual, though the hearth was an absolute tempest of worrying and yelping. Happily, an inhabitant of the kitchen made more dispatch: a lusty dame, with tucked-up gown, bare arms, and fire-flushed cheeks, rushed into the midst of us flourishing a frying-pan: and used that weapon, and her tongue, to such purpose, that the storm subsided magically, and she only remained, heaving like a sea after a high wind, when her master entered on the scene.

'What the devil is the matter?' he asked, eyeing me in a manner that I could ill endure after this inhospitable treatment.

'What the devil, indeed!' I muttered. 'The herd of possessed swine could have had no worse spirits in them than those animals of yours, sir. You might as well leave a stranger with a brood of tigers!'

'They won't meddle with persons who touch nothing,' he remarked, putting the bottle before me, and restoring the displaced table. 'The dogs do right to be vigilant. Take a glass of wine?'

'No, thank you.'

'Not bitten, are you?'

'If I had been, I would have set my signet on the biter.'

Heathcliff's countenance relaxed into a grin.

'Come, come,' he said, 'you are flurried, Mr Lockwood. Here, take a little wine. Guests are so exceedingly rare in this house that I and my dogs, I am willing to own, hardly know how to receive them. Your health, sir!'

<div align="center">

Emily Brontë
Wuthering Heights
DENT
1907

</div>

Bulldog

<div align="center">

This poem by the author GEORGE MACBETH
(1932–1992) is one of a sequence of eighteen, entitled At Cruft's.
Each poem is written in six three-line verses and describes a different breed, wittily distilling it to its essence. The bulldog, of course, is famously associated with Sir Winston Churchill (1874–1965) – and the poem glancingly alludes to this – principally because of the similarity in their facial appearance, but also because of their shared tenacity. In truth, however, Churchill's chosen pet was the rather less invincible-looking poodle; and today's bulldogs, despite their robust appearance, are both gentle by disposition and delicate in health.

</div>

With a face
as crumpled
as crushed

paper, he
shoulders
grumpily

over the sawdust:
someone pats
his

rear, he is
sure,
nevertheless, there

is still
a war on. Everything
everywhere,

pace Leibnitz,
is for
the worst.

George MacBeth
'Bulldog', from *George MacBeth: Collected Poems 1958–1970*
MACMILLAN
1971

Nothing Serious

P.G. WODEHOUSE *(1881–1975), celebrated,*
prodigiously prolific author and superb prose stylist, kept
many dogs throughout his long life. They frequently infiltrate the
sunny uplands of his comic stories and novels. Being natural clowns,
and possessing an unselfconscious love and zest for life, dogs make
wonderful comedic characters, as well as useful plot devices when, as
here, a twist in the tale is required. This extract demonstrates Wodehouse's
understanding of the Pekinese, which was his favourite breed: he owned
several, among them Squeaky, Loopy and Boo. Here, the Peke's
imperious dismissal of Agnes, at a glance, is characteristic.

It was at this moment that there emerged from the clubhouse where it had been having a saucer of tea and a slice of cake, a Pekinese dog of hard-boiled aspect. It strolled on to the green, and approaching Agnes's ball subjected it to a pop-eyed scrutiny.

There is a vein of eccentricity in all Pekes. Here, one would have said, was a ball with little about it to arrest the attention of a thoughtful dog. It was just a regulation blue dot, slightly battered. Yet it was obvious immediately that it had touched a chord. The animal sniffed at it with every evidence of interest and pleasure. It patted it with its paw. It smelled it. Then, lying down, it took it in its mouth and began to chew meditatively.

To Agnes the mere spectacle of a dog on a green had been a thing of horror. Brought up from childhood to reverence the rules of Greens Committees, she had shuddered violently from head to foot. Recovering herself with a powerful effort, she advanced and said 'Shoo!' The Peke rolled its eyes sideways, inspected her, dismissed her as of no importance or entertainment value, and resumed its fletcherizing. Agnes advanced another step, and the schoolmistress for the second time broke her Trappist vows.

'You can't move that dog,' she said. 'It's a hazard.'

'Nonsense.'

'I beg your pardon, it is. If you get into casual water, you don't mop it up with a brush and pail, do you? Certainly you don't. You play out of it. Same thing when you get into casual dog.'

They train these schoolmistresses to reason clearly. Agnes halted, baffled. Then her eye fell on Captain Jack Fosdyke, and she saw the way out.

'There's nothing in the rules to prevent a spectator, meeting a dog on the course, from picking it up and fondling it.'

It was the schoolmistress' turn to be baffled. She bit her lip in chagrined silence.

'Jack, dear,' said Agnes, 'pick up that dog and fondle it. And,' she added, for she was a quick-thinking girl, 'when doing so, hold its head over the hole.'

It was a behest which one might have supposed that any knight, eager to win the lady's favour, would have leaped to fulfil. But Captain Jack Fosdyke did not leap. There was a dubious look on his handsome face, and he scratched his chin pensively.

'Just a moment,' he said. 'This is a thing you want to look at from every angle. Pekes are awfully nippy, you know. They make sudden darts at your ankles.'

'Well, you like a spice of danger.'

'Within reason, dear lady, within reason.'

'You once killed a lion with a sardine opener.'

'Ah, but I quelled him with the power of the human eye. The trouble with Pekes is, they're so short-sighted, they can't see the human eye, so you can't quell them with it.'

P.G. Wodehouse
Nothing Serious
HERBERT JENKINS LTD
1950

Baby Peke

KATHERINE MANSFIELD (1888-1923), *like her friend
D.H. Lawrence (see pp. 30–32), was dogged by ill-health for much
of her adult life. In an attempt to find a better climate (the disease
that eventually killed her was – again – tuberculosis), she made many
sojourns abroad. As a result, she lived apart from her husband,
John Middleton Murry (1889–1957), for much of their married life.
This extract is from one of the eloquent letters she wrote to him.
Its precision and exquisite detail are characteristic qualities of her
writing, and Mansfield's affection for dogs shines through in
this delightful description of a Pekinese puppy.*

Connie came yesterday to see me, carrying a baby Pekinese. Have you ever seen a really *baby* one about the size of a fur glove, covered with pale gold down, with paws like minute seal flappers, very large impudent eyes and ears like fried potatoes? Good God! What creatures they are. This one is a perfect complement to Wing [one of Katherine's cats]. We MUST have one. They are not in the least pampered or fussy or spoilt. They are like fairy animals. This one sat on my lap, cleaned both my hands really very carefully, polished the nails then bit off carefully each finger and thumb and then exhausted and blown with 8 fingers and two thumbs inside him, gave a great sigh and crossed his front paws and listened to the conversation. He lives on beef-steaks and loaf-sugar. His partner in life, when he is at home, is a pale blue satin bedroom slipper. Please let us have one at the Heron.

Katherine Mansfield
Katherine Mansfield's Letters to John Middleton Murry 1913–1922
CONSTABLE AND CO. LTD
1951

Twentieth-Century Dogs

This second extract by KAY WHITE *and*
J.M. EVANS *(see also pp. 12–13) highlights a key reason*
why training matters: now that dogs are no longer primarily kept,
in Western society at least, for working purposes, they are prone to
suffer from the loss of mental and physical activity and the regular
companionship and sense of security that they used to gain
from working with their owners.

The twentieth century has not proved to be a good one for dogs. In the last eighty years, their world has changed even more than our own. Dogs can no longer be allowed their freedom, the motor car has changed all that; dogs are unwelcome in many parts of our intensely farmed countryside. Dogs have had to learn to live in small houses with busy people who cannot always give them all the time and attention which the dog would like and needs. Smaller, one or two generation families mean that dogs have to be alone quite a lot, and they seldom have the opportunity to consort with their own kind, they can never roam the streets in a pack following their own inclinations. Many dogs will never in the whole of their lives experience the exhilaration of doing the work which they know they should be doing and are still capable of doing.

Kay White and J.M. Evans
How to Have a Well-Mannered Dog
ELLIOT RIGHT WAY BOOKS
1981

Collies

In her book Dog *(1966),* PATRICIA DALE-GREEN *asked two
significant questions: what is dog? And what does dog mean to us today?
In so doing, she articulated the curiosity shared by many people who have
lived with dogs: that we have a great affinity with an animal that – on the
face of it – resembles us little. The book is an unusual fund of fact and
folklore that includes detailed and exact descriptions of dogs and their
work, as in this absorbing extract.*

The Scottish collie is one of the best sheepdogs in the world. Its name comes from the old title of 'colley dog' given to the dog originally used for herding mountain sheep with black feet and masks called 'colleys'. The gifts of sight, hearing and scent are about equally combined in sheepdogs. Some have the 'wall-eye' which many farmers believe to be an advantage, for they focus on far objects with the light eye and on nearer objects with the darker eye. Much of the sheepdog's capacity for herding and rounding up livestock is inherent, and it shows great eagerness to learn. At a very early age these dogs will stalk and try to herd anything that moves, including lambs, chicks, ducklings, insects and even ripples on a pond. They stare intently at the objects of their interest – behaviour known as 'showing eye', which develops into one of the main techniques used by adult sheepdogs for controlling their flocks. Collie puppies are stimulated by the sight of sheep at ten weeks old, before they have either seen older dogs working or received any training.

Sheepdogs must be capable of great speed and endurance, have active resourceful brains and temperaments, and be calm enough to enable them to work flocks without producing panic. The training of sheepdogs depends on the quality, intelligence and inherited gifts of the individual dog and the patience of the trainer. The work is much easier if the young dog can watch an older experienced one at work. It must learn to round up sheep scattered over wide-stretching moorland, gather them into close order, drive them to fold, handle them in narrow lanes, and

hold them in the corner of a field. It is taught to go out on a wide, silent casting run round the flock, bringing strays back to the mob as unobtrusively as possible, so as to keep them cool, for if it runs straight at them they will panic. (In high country when sheep stampede downhill they have to be headed back to the flock.) The curving outrun drives sheep on the outer fringes to the centre of the circle, and as the bleating woolly mob are bunched the sheepdog sometimes trips across their backs to bring up stragglers before gathering them all into a fold. Where a team of sheepdogs are required to work large flocks there are usually three hunt-aways to one heading dog. Hunt-away dogs are trained to hunt sluggish sheep with much barking, punching and coercing on their way to shearing sheds or along highways. Heading dogs are trained to lead sheep, keeping just ahead of them.

Sheepdogs are taught ten or twelve basic commands, which enable the shepherd to convey his wishes and maintain control. Audible signals are gradually replaced by arm semaphore to prevent disturbance of the flock and to allow the shepherd to direct his dog from greater distances. The dogs are trained to check regularly by looking back towards the shepherd, and will sometimes jump on a boulder to extend their view. Dogs invisible to the shepherd may be directed by a silent whistle. It is said that in training a sheepdog you must get inside its mind, and when you have accomplished this ensure that it gets inside yours.

Border collies have a smooth gliding action, and combine a creeping feline approach to their sheep with an hypnotic eye. Fixed by the eye of a collie, sheep huddle together, mesmerized into obeying its will. Collies are very nimble in mind and body, gentle and patient, and seem to sense the absence of any members of their flocks, however large. In the Scottish Highlands many sheep get lost in drifts of snow, and collies, having the capacity to run lightly across drifts without sinking, are adept at locating buried sheep. They have exceptional powers of endurance, often covering hundreds of miles a day.

No one knows the derivation of the herding instinct of these dogs. The sheepdog seems to display the hunting technique of wolves without their savagery. Wolves will cleverly manoeuvre a herd of buffalo or deer, gathering them, hemming them in, splitting off and isolating individual members. But one sheepdog, with the co-operation of its shepherd, has to do the work of a pack of wolves, and, since it does not kill, the original purpose of the instinct (to control and organize prey) appears to have been lost.

The service rendered to man by sheepdogs is incalculable, for shepherds cannot control many sheep on their own. Collies have been seen driving sheep along lanes alone and herding them to the roadside at the approach of traffic. In Australia a small number of sheepdogs will take complete charge of flocks of several thousand sheep, allowing the stock-breeder to follow on horseback later.

The relationship between the shepherd and his dog is a very harmonious one. On remote hill farms the sheepdog is often the shepherd's only intelligent companion for weeks on end, and it not only provides him with efficient and glad service but also shows him great affection. Collies appear to have an insatiable desire for work and many pine away when too old to carry on.

Patricia Dale-Green
Dog
RUPERT HART-DAVIS LTD
1966

Praise of a Collie

The great Scottish poet NORMAN MACCAIG (1910–1996)
*wrote many poems about nature and animals. He was known for his
modesty – an unfashionable quality in this day and age – and favoured
a terse, unadorned style in his work. In this poem he deftly captures the
quintessence of the border collie, so that we see her with complete clarity in
this gentle tribute to her small, skilful life. MacCaig was a deeply humane
man who, on his own admission, 'wouldn't kill a fly'; he is reported to have
refused to do military service during the Second World War because he
'just didn't want to shoot other people'. This lends additional
poignancy and feeling to the final two lines of this poem.*

She was a small dog, neat and fluid –
Even her conversation was tiny:
She greeted you with *bow*, never *bow-wow*.

Her sons stood monumentally over her
But did what she told them. Each grew grizzled
Till it seemed he was his own mother's grandfather.

Once, gathering sheep on a showery day,
I remarked how dry she was. Pollóchan said, 'Ah,
It would take a very accurate drop to hit Lassie.'

And her tact – and tactics! When the sheep bolted
In an unforeseen direction, over the skyline
Came – who but Lassie, and not even panting.

She sailed in the dinghy like a proper sea-dog.
Where's a burn? – she's first on the other side.
She flowed through fences like a piece of black wind.

But suddenly she was old and sick and crippled ...
I grieved for Pollóchan when he took her a stroll
And put his gun to the back of her head.

Norman MacCaig
'Praise of a Collie', anthologized in *The Rattle Bag*
FABER AND FABER
1982

Terrars

ABRAHAM FLEMING *(1552?–1607) was a writer, editor,*
translator and poet who also became a clergyman. As well as
acting as the general editor of Holinshed's Chronicles *(1577), Fleming*
is remembered for translating and reinterpreting Johannes Caius's famous
book Of Englishe Dogges *(1570); Fleming's edition appeared in 1576.*
It lists and describes all the known dog breeds of the time, thereby
providing an invaluable record of their history. This extract
wonderfully epitomizes the task and nature
of the terrier.

Another sorte there is which hunteth the Foxe and the Badger or Greye onely, whom we call Terrars, because they (after the manner and custome of ferrets in searching for Connyes) creepe into the grounde, and by that meanes make afrayde, nyppe, and byte the Foxe and the Badger in such sort, that eyther they teare them in pieces with theyr teeth beyng in the bosome of the earth, or else hayle and pull them perforce out of their lurking angles, darke dongeons, and close caves, or at the least through coceved feare, drive them out of their hollow harbours, in so much that they are compelled to prepare speedy flight, and being desirous of the next (albeit not the safest) refuge, are otherwise taken and intrapped with snares and nettes layde over holes to the same purpose.

Abraham Fleming
Of Englishe Dogges
1576

Jacob

ENID BAGNOLD *(1889–1981) is much more famous for her portrayal of horses, and a girl who loved riding them – the eponymous Velvet of* National Velvet *(1935) – than for her depictions of dogs. Nevertheless, in that novel, her description of the wickedly mischievous and incorrigible fox terrier, Jacob, is as unforgettable as it is exact.*

J acob went grinning round the table, from sister to sister.

'Nobody feeds him,' ordered Mi under his breath.

His red hair boiled up on his skull fiercer than ever at Jacob's presumption.

The yard spaniels remained in the street on the doorstep through meals. They lay and leant against the front door, grouped on the step, so that the door creaked and groaned under their pressed bodies. When the door was opened from the inside they fell in. When this happened Mi sent them out again with a roar.

Jacob had been allowed in all his life. His fox terrier body, growing stout in middle age, still vibrated to a look. His lips curled and he grinned at the blink of a human eyelash. His tail ached with wagging, and even his hips waggled as he moved. But under cover of these virtues he was watchful for his benefit, watchful for human weakness, affected, a ready liar, disobedient, boastful, a sucker-up, and had a lifelong battle with Mi. Mi adored him and seldom said a kind word to him. Jacob adored Mi, and there was no one whom he would not sooner deceive. At meals Jacob wriggled and grinned from sister to sister, making a circle around Mi, whose leg was scooping for him.

Just outside the slaughter-house was a black barking dog on the end of a string. This dog had a name but no character. It barked without ceasing day and night. Nobody heard it. The Browns slept and lived and ate beside its barking. The spaniels never opened their mouths. They pressed against doors and knee and furniture. They lived for love and never got it. They were herded indiscriminately together and none knew their characteristics but Mi. The sisters felt for them what they felt for the fowls in the farmyard. Mi fed them.

But Jacob's weaknesses and affectations and dubious sincerities were thrust upon everyone's notice. When Velvet came in at the front door, and pressing back the leaning spaniels, closed it, Jacob would rise, wriggle his hips at her, bow and grin.

'How exquisite, how condescending, how flattering!' said he, bowing lower and lower, with his front legs slid out on the floor and his back legs stiff. But if asked to go for a walk not a step would he come outside unless he had business of his own with the ashbin, or wanted to taunt the chained and raging dog with the spine of a herring dragged in the dust.

The chained dog chiefly barked. But sometimes he stopped rending the unheeding air and lay silent. Then he would whirl out on his chain like a fury and fall flat, half choked. And Jacob would stand without flinching, banking on the strength of the chain, and think, 'You poor one-thoughted fool ...'

The Browns loved Jacob as they loved each other, deeply, from the back of the soul, with intolerance in daily life.

Enid Bagnold
National Velvet
WILLIAM HEINEMANN LTD
1935

Greyhounds

LAURA THOMPSON *is an author and freelance journalist whose first book,* The Dogs *(1994), won the Somerset Maugham Award. Thompson grew up among greyhounds, for her father owned racing ones. The greyhound is one of the oldest dog breeds, and has a distinguished history as the companion of kings and noblemen; as a result, and because of its exquisite elegance, it is one of the breeds most often portrayed in art. It began as a hunting or coursing dog, and for that reason is best kept on a lead when outdoors: a greyhound has a very strong drive to chase prey, and in action can reach speeds of up to 65 km (40 miles) per hour, making it impossible to catch. Despite their hunting instincts, however, greyhounds have peaceful, affectionate temperaments. These lovely extracts, palpably written from the heart, do full justice to their ethereal, athletic beauty and sweet natures.*

We had an angel dog at home but I yearned for those greyhounds. There was pride and reflected glory in walking them – I knew how successful some of them were and knew dimly that they were objects of envy although there was always the fear of treading on their paws; always when they walked beside me I could imagine those delicately bunched, costly little feet flattening and splaying beneath my lumbering shoe. The fear was doubled because I knew that these were not just my dogs. They also belonged to a world beyond me. When they leapt hungrily towards me through the bars of their kennels, their sloping eyes avid for attention and their muzzles slack around eager tongues, what enthralled me was the containment of this ordinariness, this greed for food and fuss, this dog-likeness, within these overbred, purposeful, incongruously beautiful frames. These dogs were like a phalanx of fabulous catwalk models gathered into a downmarket pub, roaring over packets of crisps and – as girls will – wanting to catch the eyes of men who were less glorious than they, but not therefore more human. So these were my dogs, and I loved them as dogs, but I somehow felt privileged to be able to do so. ...

Commutering was a big, brindle dog, a very male-looking dog, with ears that liked to prick themselves into tall triangles. He won many open races. Our house is full of his beautiful prizes. We keep bottles in wine-coolers won by him, serve the wine in glasses won by him, placed on trays won by him. In 1970 he broke the track record at the long-closed, pre-metric West Ham stadium, so he will always be the fastest dog in the world over 700 yards. He was loved for the fact that he was one of the few greyhounds – 'They're the stupid ones, really,' my father would say – that will always give their all to a race and run it from the heart. He looked as he ran: very fine, very gentlemanly, class and dependability both beyond question, a Bentley of a dog.

One of the pleasures of my life then was to run a slow, firm hand down the thin tiger stripes of his long back and to see the streaks appearing one by one, tight, groomed, alert and shimmering with bone. He welcomed one wildly at the kennels, thrusting towards one with his head flat and his mouth agape, like a dragon.

His reputation was considerable and, in the way of some sportsmen, women, animals, he was always regarded with admiring respect, so one was all the more intoxicated by his nature, which was loyal, warm, stalwart, and speckled with silliness. He was the sort of dog that makes me feel that he would know me still if he were alive today.

I feel now that he forged a partnership with my father, whom I can still see casually fondling the sensitive brindle ears. They understood one another. Throughout his life, Commutering did the right thing by my father: he tried and he won and he loved. ...

Every true dog man will want to own a dog and bring his love closer to him. If he does own, as like as not you will see him at his trainer's kennels on a Sunday, pub face cramped with joviality, leisure clothes as pronounced as billboards, interspersing the dog talk with a bit of chat about his haulage company or his furniture warehouse as he absently fondles the ears of the greyhound he has come to see. On the back seat of his BMW is a box of dog biscuits; on its bonnet there may well be a small silver greyhound. I met a man who, every week, visited a bitch that he had paid to keep at the kennels for the ten years or so since she had stopped

racing. Her ribs showed like bars on an electric fire, her back was humped, there was nothing left of her face but eyes and she walked uncertainly, as if on stilts. She was too tired and weakened to show joy at the approach of her owner, but one could see it in the slow lengthening and relaxation of the lines of her head. As the man talked dog talk, he held her salty muzzle in place at his hip. The bitch stood beside him, perfectly still within the helpless quivering of her body, receiving the gently rhythmic touch of affection.

Although this scene stopped me going to the kennels for a while – I simply couldn't bear to watch as everything about the dog declined except her love and trust – writing this book has meant that I would start visiting again. On perhaps the first of these visits, I learned that the bitch had died. The tiny space that opened inside my heart was nothing compared with how I would have felt had I seen her every week; of necessity there are gaps in one's dealings with greyhounds. Better just to learn that they have died. Better not to think about it at all.

It is dangerous to get too fond of them. I was able to put years between my memories and myself with dogs like Commutering and London Lights, to put them

into another dimension, turn them into symbols of my childhood, but the dogs we own now, the Jerpoint dogs, I may live with forever: Jerpoint Daley, wildly lovable, pinning his paws to your shoulders like a rampant dance partner; Jerpoint Joey, gazing up at you in touching submission; Jerpoint Ali, my secret favourite, relentlessly greedy, her hindquarters bustling like a little housewife's as she walks along beside you. And the litter of pups that came over from Ireland: my father had high hopes of these, which by the time this book comes out will have been either satisfied or shattered. There were two black-and-white males, one of them a real and almost conscious beauty, already standing calm and still and confident, as if on a winner's rostrum. There was a wild and rumbustious dark brindle with a triangular, reptile head. There was a fascinatingly huge and skinny black bitch with the long back, predatory legs, loping tread and hanging head of a wolf. There was a smaller, prettier bitch and a quieter, honey brindle dog, who trotted at your side with his head in the air, like a thin and tiny horse. We visited them when they had just arrived. I looked at them, and instantly sealed my ineluctable bond; my father, hiding his pleasure at the sight of them cavorting round their pens, watched and gave out sidelong pronouncements. His sole caveat – normally he'd have had too many to bother voicing them – was that the dark brindle seemed to have a dodgy back foot that he threw sideways when he ran. I couldn't see what my father meant; I thought that he was trying to counterbalance the casual stretch of his hand towards the eager muzzles.

We stood and watched as they performed for us. Very new, they seemed to me, their limbs still slightly slippery, their coats still soft and loose; a little panicky in their changed circumstance, but because they were so young this was translating itself into an extreme energy and an artless desire to please. As we looked at them – so young, so new, so eager – the air seemed to swell with the infinity of possibility. In that moment, those dogs could have been anything.

Laura Thompson
The Dogs
HIGH STAKES PUBLISHING
2003

Pongo and Missis

DOROTHY GLADYS ('DODIE') SMITH *(1896–1990) began*
her career as an actress, but eventually turned her hand to writing.
She went on to create perhaps the most famous book about dogs ever,
The Hundred and One Dalmatians *(1956), an enduringly popular story.*
As is often the case with books that take on this after-life in the popular
imagination, the quality of Smith's original work has to some extent been
forgotten. She owned several Dalmatians, and skilfully wove into the plot
her awareness that they were originally bred to be carriage dogs: as the two
leading dogs, Pongo and Missis, travel in search of their puppies, the speed
and urgency of their journey lend a page-turning pace to the narrative.
The following extract is a peaceful interlude in their adventures.

Pongo and Missis jumped on to the four-poster and relaxed in bliss.

'No one will come up here until this evening,' said the Spaniel, 'because Sir Charles can't manage the stairs until John gets back. The fire should last some hours yet – we always light it for Sir Charles to have his bath in front of it. No new-fangled plumbing in this house. Sleep well, my children.'

The sunlight, the firelight, the tapestried walls were all so beautiful that it seemed a waste not to stay awake and enjoy them. So they did – for nearly a whole minute. The next thing they knew was that the Spaniel was gently waking them. The sun was already down, the fire dead, the room a little chilly. Pongo and Missis stretched sleepily.

'What you need is tea,' said the Spaniel. 'But first, a breath of air. Follow me.'

There was still a faint glow from the sunset as they wandered round the wintry, tangled garden. As Pongo looked back towards the beautiful old red-brick house, the Spaniel told them it was four hundred years old and that nobody now lived there but himself, Sir Charles and the valet, John. Most of the rooms were shut up.

'But we dust them, sometimes,' he said. 'That's a very long walk for me.'

The great window was lit by the flicker of firelight. 'It's in there we sit, mostly,' the Spaniel told them. 'We should be warmer in one of the smaller rooms but Sir Charles likes to be in the Great Hall.' A silvery bell tinkled. 'There! He's ringing for me. Tea's ready. Now, do just as I tell you.'

He led them indoors and then into a large high room at the far end of which was an enormous fire. In front of it sat an old gentleman, but they could not yet see him very well because there was a screen round the back of his chair.

'Please lie down at the back of the screen,' whispered the Spaniel. 'Later, Sir Charles will fall asleep and you can come closer to the fire.'

As Pongo and Missis tiptoed to the back of the screen, they noticed that there was a large table beside Sir Charles on which was his luncheon tray – finished with now, and neatly covered by a table-napkin – and everything necessary for tea. Water was already boiling in a silver kettle over a spirit lamp. Sir Charles filled the teapot and put the tea-cosy on. Then he lifted a silver cover from a plate on which there were a number of slices of bread. By now the Spaniel had joined him and was thumping his tail.

'Hungry, are you?' said Sir Charles. 'Well, we've a good fire for our toast.'

Then he put a slice of bread on a toasting fork. It was no ordinary toasting fork for it was made of iron and nearly four feet long. It was really meant for pushing logs into position. But it was just what Sir Charles needed, and he handled it with great skill, avoiding the flaming logs and toasting the bread where the wood glowed red hot. A slice of toast was ready in no time. Sir Charles buttered it thickly and offered a piece to the Spaniel, who ate it while Sir Charles watched.

Missis was a little surprised that the courteous Spaniel had not offered her the first piece. She was even more surprised when he received a second piece and ate that, too, while Sir Charles watched. She began to feel very hungry – and very anxious. Surely the kind Spaniel had not invited them to tea just to watch him eat? Then a third piece of toast was offered – and this time Sir Charles happened to turn away. Instantly the Spaniel dropped the toast behind the screen. Piece after piece travelled this way to Pongo and Missis, with the Spaniel only eating one now and then – when Sir Charles happened to be looking. Missis felt ashamed of her hungry suspicions.

'Never known you with such a good appetite, my boy,' said the old gentleman, delightedly. And he made slice after slice of toast until all the bread was gone. Then cakes were handed on in the same way. And then Sir Charles offered the Spaniel a silver bowl of tea. This was put down so close to the edge of the screen that Pongo and Missis were able to drink some while Sir Charles was looking the other way. When he saw the bowl was empty, he filled it again and again so everyone had enough. Pongo and Missis had always had splendid food, but they

had never before had hot buttered toast and sweet milky tea. It was a meal they always remembered.

At last Sir Charles rose stiffly, put another log on the fire, and then settled back in his chair and closed his eyes. Soon he was asleep and the Spaniel beckoned Pongo and Missis to the fire. They sat on the warm hearth and looked up at the old gentleman. His face was deeply lined and all the lines drooped and somehow he had a look of the Spaniel – or the Spaniel had a look of Sir Charles. Both of them were lit by the firelight and beyond them was the great window, now blue with evening.

'We ought to be on our way,' whispered Pongo to Missis. But it was so warm, so quiet, and they were both so full of buttered toast that they drifted into a light and delightful sleep.

Pongo awoke with a start. Surely someone had spoken his name?

The fire was no longer blazing brightly but there was enough light to see that the old gentleman was awake and leaning forward.

'Well, if that isn't Pongo and his missis,' he murmured, smilingly. 'Well, well! What a pleasure! What a pleasure!'

Missis had opened her eyes now.

The Spaniel whispered: 'Don't move, either of you.'

'Can *you* see them?' said the old gentleman, putting his hand on the Spaniel's head. 'If you can, don't be frightened. They won't hurt you. You'd have liked them. Let's see, they must have died fifty years before you were born – more than that. They were the first dogs I ever knew. I used to ask my mother to stop the carriage and let them get inside – I couldn't bear to see them running behind. So in the end, they just became house dogs. How often they sat there in the firelight. Hey, you two! If dogs *can* come back, why haven't you come back before?'

Then Pongo knew that Sir Charles thought they were ghost dogs. And he remembered that Mr Dearly had named him 'Pongo' because it was a name given to many Dalmatians of those earlier days when they ran behind carriages. Sir Charles had taken him and Missis for Dalmatians he had known in his childhood.

'Probably my fault,' the old gentleman went on. 'I've never been what they call "psychic" nowadays. This house is supposed to be full of ghosts but *I've* never seen any. I dare say I'm only seeing you because I'm pretty close to the edge now – and quite time, too. I'm more than ready. Well, what a joy to know that dogs go on,

too – I've always hoped it. Good news for you, too, my boy.' He fondled the Spaniel's ears. 'Well, Pongo and his pretty wife, after all these years! Can't see you so well, now, but I shall remember!'

The fire was sinking lower and lower. They could no longer see the old gentleman's face, but soon his even breathing told them he was asleep again. The Spaniel rose quietly.

'Come with me now,' he whispered, 'for John will be back soon to get supper. You have given my dear old pet a great pleasure. I am deeply grateful.'

They tiptoed out of the vast, dark hall and made their way to the kitchen, where the Spaniel pressed more food on them.

'Just a few substantial biscuits – my tin is always left open for me when John is away.'

Then they had a last drink of water and the Spaniel gave Pongo directions for reaching Suffolk. It was full of 'rights' and 'lefts' and Missis did not take in one word. The Spaniel noticed her dazed look and said playfully:

'Now which is your right paw?'

'One of the front ones,' said Missis, brightly. At which Pongo and the Spaniel laughed in a very masculine way.

Then they thanked the Spaniel and said good-bye. Missis said she would always remember that day.

'So shall I,' said the Spaniel, smiling at her. 'Ah, Pongo, what a lucky dog you are!'

'I know it,' said Pongo, looking proudly at Missis.

Then they were off.

After they had been running off across the fields for some minutes, Missis said anxiously:

'How's your leg, Pongo?'

'Much, much better. Oh, Missis, I am ashamed of myself. I made such a fuss this morning. It was partly rage. Pain hurts more when one is angry. You were such a comfort to me – and so brave.'

'And you were a comfort to me, the night we left London,' said Missus. 'It will be all right as long as we never lose courage both together.'

'I'm glad you did not let me bite that small human.'

'*Nothing* should ever make a dog bite a human,' said Missis, in a virtuous voice.

Pongo remembered something. 'You said only the night before last that you were going to tear Cruella de Vil to pieces.'

'That is different,' said Missis, grimly. 'I do not consider Cruella de Vil *is* human.'

Thinking of Cruella made them anxious for the puppies and they ran on faster, without talking any more for a long time. Then Missis said:

'Pongo, how far away from the puppies are we now?'

'With good luck we should reach them tomorrow morning,' said Pongo.

Just before midnight they came to the market town of Sudbury. Pongo paused as they crossed the bridge over the River Stour.

'Here we enter Suffolk,' he said, triumphantly.

They ran on through the quiet streets of old houses and into the market square. They had hoped they might meet some dog and hear if any news of the puppies had come at the Twilight Barking, but not so much as a cat had been stirring. While they were drinking at the fountain, church clocks began to strike midnight.

Missis said gladly: 'Oh, Pongo, it's tomorrow! Now we shall be with our puppies today!'

Dodie Smith
The Hundred and One Dalmatians
WILLIAM HEINEMANN LTD
1956

Tulip's Puppies

J.R. ACKERLEY *(1896–1967) was a writer and editor.*
His book My Dog Tulip *(1956) is a biography of his own dog, Queenie,*
which was an Alsatian (or German shepherd) bitch. Ackerley had not owned
a dog prior to taking 'Tulip' on, and his account of the struggle to manage
and understand her is amusing, forensically honest, and moving: she became,
as he acknowledged, 'the love of his life'. In describing how this came about,
Ackerley created a work that provides another instance of the strange power
that dogs exert, drawing from humans profound and lasting emotion –
in this case, of a kind that the author experienced neither
before nor after owning his dog.

For a month [Tulip] was the perfect mother. Enchanting to watch in her concern for and pride in her offspring, she tirelessly cleaned up after them, swabbing their little posteriors whenever they defecated or piddled – in itself a non-stop task – and eating up all their excreta. It was wonderfully pretty to see her reclining there, while her children scrambled and pushed for her teats, looking down maternally at them with her great ears cocked forward, nosing among them the moment she smelt the odour of ordure, sorting out the guilty one, rolling it over onto its back with her sharp black nose and, disregarding its protesting squeals, vigorously licking its parts until they were clean. In spite of her vigilance, however, the blanket on which they lay soon got drenched, and I would change it for her daily, removing the puppies in a basin to some temporary abode, an event that always put her in a great taking. Twice a day too, on Miss Canvey's [the vet's] instructions, I took her for a short walk to afford her a brief respite from nursing. She came when I called her, though reluctantly, barking her anxiety all the way down in the lift: two or three hundred yards along the Embankment were as far as she would ever go. Halting then in a resolute manner she would challenge

me to take another step; I would turn, and home she would hasten as fast as she could without actually deserting me, looking back at me all the time as though to say 'How you lag!', fly up the stairs (she could wait for no lift), scratch impatiently at the door (I could not be quick enough with my keys), and race down the passage to rejoin her infants.

Then she began to get bored. Their rapidly increasing size and insatiable appetites put a strain on her of course; when they added to all this the growth of little pricking teeth she started to abdicate. Suddenly, while the now quite hefty children fought and elbowed each other aside to get at her most rewarding teats, she would rise to her feet and, with three or four of them who had got a better grip than the rest suspended like strap-hangers beneath her, emit one of those noisy, cavernous yawns that Alsatians are so good at, disembarrass herself of her encumbrances with a stretch and a shake, vault lightly out of the box and retire to the divan in my sitting-room for a peaceful doze, leaving a chorus of shrill dismay behind her. With the onset of her boredom came the onset of my own, for the less she fed them the more I had to. Also they began to wish to see the world and the skirting board no longer contained them. Clambering upon each other's backs in the middle of the night, they would fall headlong over the edge and set up a plaintive, incessant wailing until I woke and returned them to the fold. Soon afterwards they would do it again. All creatures have different characters and it is reasonable to suppose that some will be worse than others; two of the four little bitches in Tulip's family were the first to climb out of the box and the most persistent in doing so. With lack of sleep my temper began to fray. Converting my small dining-room into a pen by removing the carpet and tacking chicken wire to the legs of the furniture, I transferred my guests to that. It was no time before, still led by the two little bitches, they were dragging down or burrowing under these barriers too. Their third and last arena was my open-air terrace, where my double concern was to rig up contraptions that would prevent them from re-entering the flat or crawling between the balusters of the balustrade to fall sixty feet into the road below. These contraptions, too, they seemed endlessly bent on demolishing. They were charming, whimsical little creatures; they were also positively

maddening, and exasperated me to such an extent that I sometimes gave them a cuff for disobedience and made them squeak, which was both an unkind and a useless thing to do, for they could not know what obedience was. Tulip, on these occasions, would hurry out from her *dolce far niente* to see what was afoot; she had practically abandoned them, but still took a proprietary interest in their welfare.

Also in their food. On dear Miss Canvey's instructions I was now wearing myself out supplying the hungry stomachs with four meals a day, mixing milk dishes, where there was no milk [because of rationing], out of babies' milk powder (procured on false pretences from various chemists) and Robinson's Patent Oats or Barley. Tulip, who had her daily pound of horse-flesh, would come yawning and stretching from her repose and gently insert her own head among those of her children. Naturally a few laps of her large tongue sufficed to scoop up most of the warm liquid, before her jostling brood (who got actually into the dish in their anxiety and paddled about) had managed to suck more than a drop from the rapidly sinking surface. Soon a solider diet was prescribed, trenchers of carefully boned fish or minced raw horse-meat, mixed with wheatflakes and broken rusk ...

As they ate they grew; as they grew they waxed more eloquent. They began to growl and to utter little barks as they lurched about the terrace on their unsteady legs in that apparently purposeful but ultimately disastrous way drunks move, squabbling, playing tug-of-war and pulling one another's tails. Tulip herself would have a game with them when she felt disposed, plant her large paws on them like a cat with a mouse, or race up and down the terrace in front of them, while they fell over themselves in their blundering efforts to imitate her. This delighted them, and when she retired into the flat they would follow. The barrier I had erected in the doorway was high, but they constantly contrived to crawl over it. After their occupation of the dining-room the place had looked like a stable, and smelt like one; urine and excreta had soaked through all the protective layers of paper I had put down and glued them to the linoleum. Much work with a scrubbing-brush and disinfectant was needed to restore the room to its original function. Now that the carpet was back they could not be readmitted. They could not be kept out.

J.R. Ackerley
My Dog Tulip
SECKER & WARBURG
1956

Truls and Pella Arrive

The Swedish author EDITH UNNERSTAD (1900–1982) *wrote
many books, most of them for children. In the aftermath of the Second
World War, Swedish children's literature was strongly influenced by anti-
authoritarian ideals, and in this extract from Unnerstad's delightful book
Little O (1965), the diminutive heroine decides to take matters into her own
small hands – and triumphs. The happy, unmenaced world shown here, in
which adults gladly help children and can be trusted not to have sinister
ulterior motives, is hardly imaginable now: our anxieties about keeping
children constantly under surveillance fetter their freedom, despite the
fact that, via the Internet, they now have access to the whole world as a
virtual playground. Unnerstad's keen sympathy for the young
is evident in her description of the spontaneous way in
which the puppies and their new mistress
immediately strike up a bond.*

Little O was alone at home. She had had measles. But the rash had gone and she was already up again, although she couldn't go out just yet. The Urchin and Knut were to have kept her company, because Mummy had gone out to a sewing circle. But Pelle Göran from number thirty-nine had come along and asked if the Urchin would go and play in his garden. And the Urchin had gone. Then Knut had had to go to the library with a book. And of course he got stuck there. And as a result Little O was quite alone.

At first she played with her dolls for a bit. Then she drew little men and looked at picture books. But she had been doing that for a whole week so it soon became boring ...

Then she caught sight of the telephone on the hall table. It would be rather fun to ring up somebody and chat for a bit. She wouldn't feel so forsaken, then. But did she dare?

She had often talked to Daddy and Aunt Bella over the phone. But someone else had always rung up for her. She mustn't ring up all by herself, for she was too little said the others. She couldn't read numbers yet. Well, she could count up to

twenty, but she didn't understand the numbers on the dial. If she tried to ring up sometimes, either Mummy or somebody else would always come and take the receiver away from her.

'Ring up on your own telephone,' they said.

That stupid old red toy telephone that couldn't answer a word!

But now that none of the others were at home they couldn't prevent her from ringing up on the real one. That decided the matter.

Little O clambered up on to a chair and lifted the receiver.

Tut-tut-tut, it said in her ear.

She stuck her chubby little forefinger into a hole and began turning the dial. She knew well enough how to ring up, although nobody believed she did. As though it were difficult!

It was a long time before she got any reply. She poked and whirled a great many times. But at last it worked. ...

'Hullo!'

It was a deep voice replying. It was certainly Daddy. Yes, of course it must be Daddy. Good! How splendid ...

'Hullo!' said Little O. 'This is me!'

'Oh yes, and who is me?' asked the voice.

'You,' said Little O, and laughed. 'You're Daddy, of course.'

'Am I?' said the voice, laughing too. 'I wonder. And who are you, then?'

Daddy, the rascal, he was always joking!

'Can't you hear it's Little O?' she said. 'Dear Daddy, can't you come home soon? Mummy's gone to the sewskirtle and I'm so bored.'

She thought a sewing circle always sewed skirts.

'Poor little soul,' said the voice. 'Haven't you anybody to play with?'

'No, they've all gone out. Dear Daddy, come home!'

'Well, you know, it's a pity,' said the voice, 'but actually I'm not your daddy.'

And now he sounded serious and not joking, and when she came to think of it he didn't sound a bit like Daddy after all.

'Oh,' she said, 'Is it Lindkvist from the factory then? Please, Lindkvist, tell Daddy I want to talk to him.'

'No, it's not Lindkvist either,' said the voice. 'This is number 12345. What's your daddy's number?'

'Don't know,' said Little O. 'But can't you come and play with me for a bit?'

'Thank you very much, but really I haven't played for a very long time, so I'm afraid I'm not up to it,' said the voice, with a little laugh.

There was silence for a moment. Little O wondered whether to say good-bye and put down the receiver. But then the voice came again and now it sounded both lively and resourceful.

'Listen, now, wait a bit,' it said. 'Maybe ... tell me, whereabouts do you live?'

'One hundred and nineteen West St Peter's Street,' said Little O.

She knew that, for she had been taught it so that she wouldn't ever go and get lost.

'Is that so, why it's quite near here,' said the voice. 'And what's your daddy called?'

'He's called Daddy Per Ivar Patrik Larsson. And Mummy's called Maja Larsson. We are the Pip-Larssons.'

'Aha, then I know. Now, how would you like it if I came along and brought you some little playmates?'

'Oh please, please do,' cried Little O. 'Hurry up and come at once!'

'How many shall I bring with me?'

Little O reflected. Perhaps it wasn't a good idea to invite too many when she couldn't ask Mummy first.

'Two,' she said.

Then she remembered something.

'Have they had measles?' she asked uneasily. 'Because if not I might infect another child, Mummy said. Though I'm nearly well again now and I'm up all day and the day after tomorrow I'm going out, because the doctor says I may.'

Now the voice laughed heartily.

'Well, you know, I don't think there's any danger of your infecting these playmates,' it said. 'No, you needn't worry about that. Well, so long for the present. We'll soon be there, all three of us.'

Little O was so happy that she jumped off the chair and sat down plump on the floor. She ran into the kitchen and looked into the cake tins.

Yes, there were lots of cakes which she could offer her visitors. Mummy always offered children cakes when they came up to play in the flat.

Then she took the best frocks out of the dolls' drawer and dressed Rosegold and Malena so that she shouldn't have to feel ashamed of her children in front of the new playmates.

Just when she was ready there came a ring at the door. Little O rushed to open it. But – what in the world was this?

There stood a gentleman with two tubby little puppies on a lead. One was quite white, the other quite black, and both had bright brown eyes and a little pink tongue, and their coats were thick and shining. And they were absolutely full of beans! They wagged their tails and stood on their hind legs and tugged at the lead and tried to get in and greet her all at the same time.

'Oh!' said Little O.

She thought that never had she seen anything so sweet.

'How do you do, Little O,' said their owner. 'Well, here we are. The black one's name is Truls and the white one's is Pella and I promise you they are a pair of the nicest possible pups of whom nobody need ever be afraid. They are Lapland puppies. And as you see, they are longing to come in and play with you for a bit.'

Little O was so delighted that she couldn't say a word. The puppies jumped up at her and licked her hands. Their owner hung the lead on a hook in the hall and said he hadn't time to stay himself, but that he would fetch Truls and Pella in two hours' time. Then he went away.

That *was* an afternoon! You can imagine what fun Little O had. She and the puppies played hide and seek and threw a ball and had tug of war games with an old ski-ing sock. The puppies growled and barked, but only in fun, and Little O growled too as well as she could. They tore a newspaper into a thousand little bits

and rolled on the floor. They slid in the long corridor until they all three panted with exhaustion. Then Little O took them out into the kitchen and gave them cakes and milk. And she only spilled a tiny, tiny drop. Anyway, Truls and Pella licked it up afterwards so that it hardly showed.

At last she put them into the dolls' pram. The pups were so sleepy after all the games and food that they went to sleep at once, snoring as contentedly as if they were in their own home.

When Mummy came home from the sewing circle, Little O was there singing, 'Slumber little willow tree,' to Truls and Pella. Mummy clasped her hands when she saw the shaggy heads on the dolls' pillow.

'Goodness gracious me!' she said. 'Where did these little pets come from?'

'They're my playmates,' said Little O, proudly. 'I rang up on the telephone, and they came.'

'You did *what*?' asked Mummy, in amazement. 'Did you telephone and order a pair of puppies? I've never heard of such a thing!'

'Yes, when you all went off and left me like that,' said Little O. 'I was so bored and didn't know what to do, so I went out into the hall and rang up. And I could do it, Mummy, I could do it!'

... But presently the owner of the pups came to fetch them. And he explained how it had all come about. And he said his bitch had had seven puppies and he really didn't know what to do with them all. And if Mrs Larsson were willing, Little O was welcome to have a couple as a gift, he said.

'Lapland dogs are the best children's dogs there are,' he said. 'Sturdy and good-tempered. You can maul them about as much as you like without them ever getting angry.'

'Mummy!' said Little O. 'Can we have them? Oh, can we?'

'Oh, my dear child!' was all Mummy said.

Now the puppies woke up and started to play again. Mummy sat watching them as they tumbled about.

Just then Truls made a little puddle on the floor. Pella immediately sat down and made one as well. Little O was afraid and thought that now it was all up, for Mummy would certainly refuse to have puppies that made puddles.

'It was a mistake, Mummy,' she tried to explain away the mishap. 'I'm sure they won't do it again.'

But Mummy mopped up the puddles and said, 'Yes, it means a whole lot of extra work, of course. And I shall have to see what Daddy thinks about it all.'

Just then Daddy arrived home.

'Hullo, what's all this?' he said in astonishment.

Little O flung herself into his arms. But she needn't have been worried. Because obviously Daddy couldn't say no to Truls and Pella when he heard what had happened about them.

'There's no refusing those two,' he said.

Little O pranced with delight. Then she hugged Mummy and Daddy and the owner of the puppies too, and thanked him again and again.

'You're very welcome,' said the puppies' owner. 'Now you need never feel lonely again when Mummy goes to the sewskirtle.'

Mummy sighed and smiled at once.

'Well, we're a little crazy, of course,' she said. 'Now we've got two horses and a cat and two dogs. Not to mention seven children.'

'We must be thankful that she didn't ring up for an elephant,' said Daddy.

'I may do that next time,' said Little O.

'That I can well believe,' said Mummy.

Edith Unnerstad
Little O
PUFFIN BOOKS
1968

Dog Toby

Dogs – especially small terriers, or poodles –
being agile, excitable and eager, make endearing entertainers.
Performing dogs, of course, are much more than merely amiable buffoons:
it has been claimed that a poodle that could count and calculate brought
in enough money to support its owner's family for fifteen years. Toby dogs
were used to enhance the appeal of a show, but also to go round
with a hat to collect money from the punters.

Among the most popular of performing dogs is Dog Toby of the 'Punch and Judy' puppet show. Although this was first performed in Covent Garden in 1662, it was not until the eighteen-twenties that a showman trained his dog to perform with the puppets in the booth, and a live dog became the most popular feature of the show. Toby wears a ruff garnished with bells to frighten the Devil away from his master, and his function is to sit on the playboard and bite Punch's nose at the appropriate cues. He is also sometimes expected to shake Punch's hand, to smoke, and even to sing.

<div align="center">

Patricia Dale-Green

Dog

RUPERT HART-DAVIS LTD

1966

</div>

London Dogs

PETER ACKROYD *(born 1949) is London born, and in*
a succession of superbly atmospheric works, both biographical
and fictional, has made the evocation of London – its history, character,
authors and other inhabitants – all his own. In this extract from his
award-winning book London: The Biography *(2000), he sends the dogs*
of London leaping and scurrying through its streets, and rapidly daubs in
vivid details of their various lives – details that are the verbal equivalents
of illuminated miniatures in the margins of a medieval manuscript or
map. Characteristically quick-witted, Ackroyd's writing skilfully springs
its surprise facts: within two paragraphs his loosed dogs have fetched
up as strays, for which a new 'asylum', Battersea Dogs Home, must be
founded. The extract is followed by an article by Charles Dickens,
one of Ackroyd's great inspirations.

Dogs appear in almost every depiction of a London 'street scene', prancing on the road and mingling joyfully with horses and pedestrians alike. There have been dogs at every stage of the city's history, accompanying families in their walks along the fields, barking at passing processions, eager and fierce during riots, growling at and fighting each other in obscure disputes over London territory. In the twelfth century a royal edict declared that 'if a greedy ravening dog shall bite' a 'Royal beast', then its owner forfeited his life. So we may imagine the inhabitants of early medieval London nervously taking out their dogs for sport, or pastime, or hunting, in any of the fields and meadows beyond the walls of the city. Yet the dogs which were taken to these areas had to be 'expeditated'; their claws were cut down to the balls of their feet to stop them from running after deer.

A proclamation was made in 1837 'that dogs shall not wander in the City at large'; yet in the same order a distinction was made between wild or wandering dogs and household dogs. So the concept of the 'pet' existed in medieval London. The most prized of London dogs was the mastiff. Many were sent as gifts to prominent persons abroad, and a German traveller of the sixteenth century noted that some of those dogs 'are so large and heavy that if they have to be transported long distances, they are provided with shoes so that they do not wear out their feet'. They were also used as guard dogs and in the records of London Bridge there are payments made in compensation to those who had been bitten or hurt by the mastiff hounds. The major problem in the city, however, has always been that of strays. A notice at the newly built St Katherine Docks, by the Tower of London, dated 23 September 1831, warned that 'the Gate Keepers will prevent the admission of DOGS, unless the Owners shall have them fastened by a Cord or Handkerchief'. The principal complaint against the animals was that they wreaked 'Considerable Injury' upon goods, but the age of commerce was also the age of philanthropy. In the mid-nineteenth century a Home for Lost and Starving Dogs was established in London; this was the first instance of canine welfare in the city. 'When it first opened there was a disposition to laugh,' 'Aleph' wrote in 1863, 'but subscribers were found, and the asylum flourishes'; removed to Battersea in 1871 after complaints in the neighbourhood about the noise, it flourishes still, as the Battersea Dogs Home.

<div style="text-align:center">

Peter Ackroyd
London: The Biography
CHATTO & WINDUS
2000

</div>

Two Dog-Shows

CHARLES DICKENS (1812–1870), *masterly and prolific author, is well known for his championing of the poor and the oppressed. He was also fascinated by character in all its forms. It is hardly a surprise, therefore, to find him, in this extract from an article entitled 'Two Dog-Shows', scrutinizing the different characters of dog breeds, and celebrating the creation of the 'Holloway asylum' that would become Battersea Dogs and Cats Home. Since its foundation in 1860, the home, a charity that never turns away a dog or cat in need of help, has taken in more than 3 million strays.*

It has been said that every individual member of the human race bears in his outward form a resemblance to some animal; and I really believe that (you, the reader, and I, the writer of these words, excepted) this is very generally the case. ... Let any one pay a visit to the Zoological Gardens with this theory of resemblances in his mind, and see how continually he will be reminded of his friends. ...

But what is more remarkable is, that there is one single tribe of animals, and that the most mixed up with man of all, whose different members recall to us constantly, different types of humanity. It is impossible to see a large collection of dogs together, without being continually reminded of the countenances of people you have met or known; of their countenances, and of their ways.

In that great canine competition which drew crowds, some week or two ago, to Islington, there were furnished many wonderful opportunities for moralising on humanity. It was difficult to keep the fancy within bounds. ...

Great monster boar-hound, alone worth a moderate journey to get a sight of; ... sweet-faced muff from St Bernard, whose small intellect is what might be expected of a race living on the top of a mountain with only monks for company; small shadowy-faced Maltese terrier; supple fox-hound; beloved pug; detested greyhound of Italy; otter-hounds that look like north country gamekeepers

Curiously enough, within a mile of that great dog-show ... there existed, and exists still, another dog-show of a very different kind, and forming as complete a contrast to the first as can well be imagined. As you enter the enclosure of this

other dog-show, which you approach by certain small thoroughfares of the Holloway district, you find yourself in a queer region, which looks, at first, like a combination of playground and mews. The playground is enclosed on three sides by walls, and on the fourth by a screen of iron cage-work. As soon as you come within sight of this cage some twenty or thirty dogs of every conceivable and inconceivable breed, rush towards the bars, and, flattening their poor snouts against the wires, ask in their own peculiar and most forcible language whether you are their master come at last to claim them?

For this second dog-show is nothing more nor less than the show of the Lost Dogs of the metropolis – the poor vagrant homeless curs that one sees looking out for a dinner in the gutter, or curled up in a doorway taking refuge from their troubles in sleep. To rescue these miserable animals from slow starvation; to provide an asylum where, if it is of the slightest use, they can be restored with food, and kept till a situation can be found for them; or where the utterly useless and diseased cur can be in an instant put out of his misery with a dose of prussic acid; – to effect these objects, and also to provide a means of restoring lost dogs to their owners, a society has actually been formed, and has worked for some year and a half with very tolerable success. ...

Among the unappreciated and lost dogs of Holloway ... there seemed a sort of fellowship of misery, whilst their urbane and sociable qualities were perfectly irresistible. They were not conspicuous in the matter of breed, it must be owned. A tolerable Newfoundland dog, a deer-hound of some pretensions, a setter, and one or two decent terriers, were among the company; but for the most part the architecture of these canine vagrants was decidedly of the composite order. That particular member of the dog tribe, with whom the reader is so well acquainted, and who represents the great and important family of the mongrels, was there in all his – absence of – glory. Poor beast, with his long tail left, not to please

Sir Edwin Landseer, but because nobody thought it worth while to cut it, with his notched pendent ears, with his heavy paws, his ignoble countenance, and servile smile of conciliation, snuffing hither and thither, running to and fro, undecided, uncared for, not wanted, timid, supplicatory – there he was, the embodiment of everything that is pitiful, the same poor pattering wretch who follows you along the deserted streets at night, and whose eyes haunt you as you lie in bed after you have locked him out of your house.

To befriend this poor unhappy animal a certain band of humanely-disposed persons has established this Holloway asylum, and a system has been got to work which has actually, since October, 1860, rescued at least a thousand lost or homeless dogs from starvation. ... It is the kind of institution which a very sensitive person who had suffered acutely from witnessing the misery of a starving animal would wish for, without imagining for a moment that it could ever seriously exist.

It *does* seriously exist, though. An institution in this practical country founded on a sentiment. The dogs are, for the most part, of little or no worth. I don't think the Duke of Beaufort would have much to say to the beagle I saw sniffing about in the enclosure, and I imagine that the stout man, who owned the smaller terriers at the [Islington] show, would have had little to say to the black-and-tan specimens, which mustered strong in numbers, but weak in claims to admiration, in the shut-up house The 'Home' is a very small establishment, with nothing imposing about it ... I think it is rather hard to laugh this humane effort to scorn. ... At all events, and whether the sentiment be wholesome or morbid, it is worthy of record that such a place exists; an extraordinary monument of the remarkable affection with which English people regard the race of dogs; an evidence of that hidden fund of feeling which survives in some hearts even the rough ordeal of London life in the nineteenth century.

<div align="center">

Charles Dickens
'Two Dog-Shows', in *All the Year Round*
1862

</div>

Red Dog

LOUIS DE BERNIÈRES *(born 1954) is a novelist with a
keen sense of the absurd and the comedic. His book* Red Dog *(2001),
from which this extract is taken, describes the itinerant life of a dog called
Tally Ho, which really existed in the 1970s. De Bernières's story vividly
conveys the dog's energy, as Tally travels through Western Australia,
meeting with good and ill fortune. The tale poignantly reveals the random
nature of many dogs' lives, and how they are always having to guess at
what their human companions may do; the fact that Tally is a
'canine dustbin' will count for much in his eventual fate.*

Strewth,' exclaimed Jack Collins, 'that dog's a real stinker! I don't know how he puts up with himself. If I dropped bombs like that, I'd walk around with my head in a paper bag, just to protect myself.'

'Everyone likes their own smells,' said Mrs Collins. Jack raised his eyebrows and smirked at her, so she added, 'Or so they say.'

'Well, it's too much for me, Maureen. He's going to have to go out in the yard.'

'It's his diet,' said Maureen, 'eating what he eats, it's going to make smells. And he gulps it down so fast, he must be swallowing air.'

'Tally would let off even if you fed him on roses,' said her husband, shaking his head, half in wonder. 'Shame it's a talent you can't be paid for. We'd all be millionaires. You know what I think? We should hire him out to the airforce. You could drop him in enemy territory, he'd neutralise it for three days, more or less, and then you could send in the paratroops. It'd be a new era in airborne warfare.'

'Don't light any matches, he's done it again,' said Maureen, holding her nose with her left hand, and waving her right hand back and forth across her face. 'Tally, you're a bad dog.'

Tally Ho looked up at her with one yellow eye, keeping the other one closed for the sake of economy, and thumped his tail on the floor a couple of times. He had noted the affectionate tone of her voice, and took her words for praise. He was lying on his side, a little bit bloated after gnawing on one of his oldest bones. He was only a year old, so his oldest bone was not too old, but it certainly had plenty of flavours, and all the wind-creating properties of which Tally was particularly fond.

Tally was the most notorious canine dustbin in the whole neighbourhood, and people delighted in presenting him with unlikely objects and encouraging him to eat them. With apparent relish he ate paper bags, sticks, dead rats, butterflies, feathers, apple peel, eggshells, used tissues and socks. On top of that, Tally ate the same food as the rest of the family, and at this moment carried in his stomach a goodly load of yesterday's mashed potato, gravy and steak and kidney pie.

This is not to say that Tally ever raided dustbins or browsed on garbage. That would have been very much beneath his dignity, and in any case, he had never found it necessary. He had never lacked success in obtaining perfectly good food from human beings, and ate odd things in good faith, just because human beings offered them to him. He made up his own mind as to what was worth eating again, and whilst he would probably be quite happy to eat more eggshells, as long as they still had some traces of egg in them, he probably wouldn't try another feather.

'I'm going to take him to the airport,' said Jack, 'he can work off some energy, and get some of that gas out.' He went to the door and turned. Tally Ho was looking up at him expectantly, both yellow eyes open this time. His ears had pricked up at the magic word 'airport'.

'Run time,' said Jack, and Tally sprang to his feet in an instant, bouncing up and down with pleasure as if the floor was a trampoline. The caravan shook and the glasses and cutlery in the cupboard started to rattle. Tally Ho seemed to be grinning with pleasure. He was shaking his head from side to side and yelping.

'Get him out before he demolishes the whole place,' said Maureen, and Jack stood aside for Tally Ho to shoot out of the door like the cork from a bottle of champagne. He bounded out of the small garden, and did some more bouncing up and down outside the car. Jack opened the back door, said 'Hop in' and Tally Ho jumped onto the back seat. In an instant he hopped over and sat in the front seat. Jack opened the front passenger door and ordered 'Out!'

Tally looked at him coolly, and then deliberately looked away. He had suddenly gone deaf, it appeared, and had found something in the far distance that was terribly interesting.

'Tally, out!' repeated Jack, and Tally pretended to be looking at a magpie that was flying over the caravan.

Jack used to be in the Australian army, and he liked his orders to be obeyed. He didn't take it lightly when he was ignored by a subordinate. He picked Tally bodily off the seat, and deposited him in the back. 'Stay!' he said, wagging his forefinger at the dog, who looked up at him innocently as if he would never consider doing the slightest thing amiss. Jack closed the door and went round to the driver's side. He got in, opened all the windows, started the engine and called over his shoulder, 'No bomb-dropping in the car. Understood?'

Tally waited until the Land Rover had started off down the road, before springing lightly once more over onto the front passenger seat. He sat down quickly and stuck his head out of the window, into the breeze, so that he would have a good excuse for not hearing his master telling him to get in the back. Jack raised his eyebrows, shook his head and sighed. Tally Ho was an obstinate dog, without a doubt, and didn't consider himself to be anyone's subordinate, not even Jack's. It never occurred to him that he was anything less than equal, and in that respect you might say that he was rather like a cat, although he probably wouldn't have liked the comparison.

Louis de Bernières
Red Dog
SECKER & WARBURG
2001

Execution

*From roving dogs and strays, we vault effortlessly
upwards through the social strata, to the realms of royalty. But
privilege is no guarantee of security.* ROBERT CECIL (1563–1612),
*1st Earl of Salisbury, was a statesman during the reigns of both
Queen Elizabeth I (1533–1603) and King James I (1566–1625).
This heartbreaking piece speaks for itself.*

Then one of the executioners, pulling off her garters, espied her little dogg, which was crept under her clothes, which could not be gotten forth but by force, yet afterwards would not depart from the corpse, but came and lay betweene her head and her shoulders, which being imbrued with her bloode was caryed away and washed, as all things ells were that had any bloode was either burned or clean washed.

Robert Cecil
Account of Mary Queen of Scots' Execution, c. 1589,
extracted in *Faithful Friends: Dogs in Life and Literature*
CARROLL AND GRAF
1997

Royal Dogs

The distinguished historian SIR KEITH THOMAS *(born 1933)*
has written several works about the early modern period, and is also
known for his books Religion and the Decline of Magic *(1971)* and
Man and the Natural World *(1983), from which this pithy and incisive*
extract is taken. It reveals the universal appeal of dogs, and the access
they gain into all walks of life. And who would have guessed that
the ambitious Robert Cecil (see opposite) might metamorphose
into James I's 'little beagle'?

Then, as now, the passion for unnecessary dogs started with the royal family. The Stuarts were obsessed by them. James I had his favourite hounds, Jowler and Jewell, the latter unfortunately shot by his wife, Anne, in mistake for a deer. Anne herself was painted by Paul van Somer along with a horse and five dogs; their son Henry had his favourite horse done lifesize in 1611 by a Florentine artist and himself portrayed in the company of a red mastiff; while their daughter Elizabeth, the Winter Queen, lived surrounded by dogs, birds and horses and was notorious for preferring her pets to her children. To James, even Robert Cecil was his 'little beagle', Buckingham his 'dog Steenie'. When presented with Dr Caius's monograph on the antiquity of Cambridge University, the king is said to have remarked rather ungraciously, 'What shall I do with this book? Give me rather Dr Caius's *De Canibus*.' It is not surprising that James was accused in 1617 of loving his dogs more than his subjects.

His successors continued the tradition. Charles I's wife gave birth prematurely in 1628 after being involved in a fight between large dogs in the gallery at Greenwich; later in life she visited the diarist John Evelyn and 'recounted ... many observable stories of the sagacity of some dogs that she had formerly had'. Charles's nephew Rupert had a white poodle, Boy, who became a celebrated figure in the 1640s, attracting much satirical comment; and the king himself only parted with his own dog after receiving sentence of death in 1649. Charles II was notorious for playing with his dog at the Council table, and everyone knows someone who knew someone who knew someone who saw him walking with his spaniels. His brother James took his dogs to sea with him when he was Admiral and in 1682 in a bad shipwreck, when many sailors were drowned, was alleged to have disgraced himself by crying out, 'Save the dogs and Col. Churchill!' This was certainly a gross libel, for some at least of the dogs had to fend for themselves; it is known that Sir Charles Scarborough, the Duke's physician, engaged with Mumper, the Duke's dog, in a humiliating tussle for the last remaining plank.

<div style="text-align:center">

Keith Thomas
Man and the Natural World
PENGUIN
1983

</div>

Dog Poetry

ARCHIBALD PERCIVAL WAVELL *(1883–1950), a
British field marshal, and Viceroy of India from 1943 to 1947,
is also remembered for his much-loved anthology of poetry,* Other
Men's Flowers *(1944). Wavell's selection is entirely personal, and
begins with a poem that uses the dog as a metaphor: Francis Thompson's*
The Hound of Heaven *(1893). Wavell's love of dogs is also evident
in this Note from the anthology. In his Preface to the first edition,
he wrote, 'The Notes are not altogether my fault, the publisher asked
for them'; no doubt his publisher was delighted with the outcome,
in this instance a direct, affectionate and astute view of
the subject, confident in its partiality.*

The dog, man's most intelligent and responsive friend in the animal world, has inspired little real poetry, while that foolish quadruped the horse has been the subject of much. Swift, in the last part of *Gulliver's Travels*, endowed his horses (Houyhnhnms) with superhuman wisdom and intelligence, the last thing that horses have ever had, in the view of their riders anyway. Beauty and speed have nearly always been preferred to solid worth – this is the reason for many divorces. When the dog is celebrated in verse, it is usually as the questing hound, the beast of the chase, rather than as man's companion. Dogs bark, an unmusical sound; hounds bay – 'a cry more tuneable'.

Kipling has written the best verse on the dog-about-the-house (*The Power of the Dog*; *Dinah in Heaven*; *The Supplication of the Black Aberdeen*); but most doggy verse is inclined to be doggerel. The truth is that the dog-friend is too sensible, too homely to appeal to the poet, by whom even the sleek, egotistical promiscuous

cat is better advertised. The dog has still to live down his Eastern and biblical reputation as an unclean animal. Poor dog, his name is ill-connected in our speech: a dog's life, sick as a dog, dog's-eared, dog-tired, dogsbody, dog in the manger, dirty dog, 'grin like a dog and run about the city'. And why should the name of the dog's comparatively chaste female be such a term of opprobrium while the cat's noisier and more frequent lapses from virtue escape notice? Perhaps merely because the cat is a nocturnal amorist, while the dog, sensibly, likes to see what he is making love to – not that he seems to mind much.

Cats would never run after an electric mouse to amuse their human friends, nor retrieve a sparrow. Never mind; 'Dogged does it' is one of our best proverbs; and dogs have their Star and cats have none.

<div align="center">

A.P. Wavell
Other Men's Flowers
JONATHAN CAPE
1952

</div>

Hounds

<div align="center"></div>

<div align="center">

JOHN MASEFIELD *(1878–1967) overcame difficult early circumstances (his parents died when he was a small child, and he was apprenticed as a merchant seaman from the age of thirteen) to become a successful author and Poet Laureate from 1930 to 1967. He had a deep love of the natural world and a keen eye for the varying beauties of the animal kingdom. This poem, part of Masefield's long verse work* Reynard the Fox *(1919), bears out A.P. Wavell's remarks about hounds being peculiarly suited to description in verse (see p. 91). With an eye as expert as a huntsman's checking his pack, Masefield captures all the dogs' qualities – physical, mental and emotional. The pace of the verse also mimics the hounds' restless, eager energy.*

</div>

They were a lovely pack for looks;
Their forelegs drumsticked without crooks,
Straight, without over-tread or bend,
Muscled to gallop to the end,
With neat feet round as any cat's.
Great-chested, muscled in the slats,
Bright, clean, short-coated, broad in shoulder,
With stag-like eyes that seemed to smoulder.
The heads well-cocked, the clean necks strong,
Brows broad, ears close, the muzzles long,
And all like racers in the thighs;
Their noses exquisitely wise,
Their minds being memories of smells;
Their voices like a ring of bells;
Their sterns all spirit; cock and feather;
Their colours like the English weather,
Magpie and hare, and badger-pye,
Like minglings in a double dye,
Some smutty-nosed, some tan, none bald;
Their manners were to come when called,
Their flesh was sinew knit to bone,
Their courage like a banner blown.
Their joy to push him out of cover,
And hunt him till they rolled him over.

John Masefield
Reynard the Fox, extracted in *Other Men's Flowers*
JONATHAN CAPE
1952

Otterhounds

Dandelion Days, A Fox Under My Cloak, The Lone Swallows ... The titles of books by HENRY WILLIAMSON (1895–1977) *affirm his preoccupation with nature. His masterpiece,* Tarka the Otter (1927), *is a superb example of the way in which close and patient observation of animals – and men – yields exact, revelatory writing, full of brilliant colour, detailed physicality and the rhythms of country life. This extract speaks with the voice of experience and a profound understanding of the rituals of the hunting field. There is something almost tribal in the account of the gathering hunt-followers with their motley weapons, and the telling, like a chant or incantation, of the hounds' names. And in the centre of the piece, skilfully placed, scarred and growling, sits Deadlock, the hound that will prove fatal to Tarka.*

At half-past ten in the morning a covered motor-van stopped at the bridge below the Dark Pool. From the driver's seat three men got down, and at the sound of their footfalls deep notes came from the van. Hearing the hounds, the two terriers – Biff and Bite'm – held by a girl in jacket and short skirt of rough blue serge, yapped and strained against the chain.

Motor-cars were drawn up on one side of the road. The men, women, and children who had come to the meet of otterhounds stood by them and talked or lounged against the stone parapets of the bridge. Some men leaned on long ash poles, stained and polished with linseed oil and shod with iron and notched from the top downwards with the number of past kills, two notches crossed denoting a double-kill. The women carried smaller and slenderer poles, either of ash or male bamboo. There were blackthorn thumb-sticks, hazel-wands, staves of ground-ash; one boy held the handle of a carpet-sweeper, slightly warped. He had poked the end in some nettles, lest the wooden screw be seen by other boys. It had no notches.

Faces turned to the hound-van. Huntsman and his whipper-in each lifted a rusty pin from the staples in the back of the van and lowered the flap. Immediately hounds fell out and over each other, and to the road, shaking themselves,

whimpering, panting with pink tongues flacking, happy to be free after the crush and heat of the journey from kennels. They were admired and stroked, patted and spoken to by name; they scratched themselves and rolled and licked each others' necks; they sat and looked up at the many faces – old Harper solemnly, with eyes sunk by age, the younger hounds, still remembering their walking days, going to seek their human friends, and sniff and nuzzle pockets where biscuits, cake, and sandwiches were stored. The kennel-boy and whip called them by name and flicked gently near the more restless with his whip: Barbrook and Bellman, Boisterous and Chorister, Dewdrop, Sailoress, Coraline, and Waterwitch; Armlet, who lay down to sleep, Playboy and Actor, Render and Fencer; Hemlock the one-eyed, with Bluemaid, Hurricane, Harper, and Pitiful, the veterans; Darnel and Grinder, who sat behind Sandboy. Then two young hounds of the same litter, Dabster and Dauntless, sons of Dewdrop and Deadlock.

And there Deadlock, his black head scarred with old fights, sat on his haunches, apart and morose, watching for the yellow waistcoat of the Master. His right ear showed the mark made by the teeth of Tarka's mother two years before, when he had thrust his head into the hollow of the fallen tree. The swung thong of the whip idly flicked near Deadlock; he moved his head slightly and his eyes; from upper and lower teeth the lips were drawn, and, looking at the kennel-boy's legs, Deadlock growled. The hound hated him.

People were watching. The whipper-in felt that the hound was making him ridiculous, and flicked Deadlock with his lash, speaking sharply to him. The hound's growls grew more menacing. Between his teeth the hound yarred, the dark pupils of his eyes becoming fixed in their stare. Then seeing Dabster trotting off to the bridge the whipper-in gladly went after him. Deadlock looked away, ignoring all eyes.

Other cars descended the hill above the bridge and stopped on the left of the road. For a week in the early summer of each year, known as the Joint Week, a neighbouring Hunt visited the country of the Two Rivers, bringing their own hounds with them, so that the home pack might rest every other day of the six hunting days. Other otter-hunters came from their rivers which flowed into the seas of Britain west and south and east. Their uniforms were coloured as the dragonflies over the river. There were grey pot-hats, dark blue jackets and stockings, and white breeches of the Cheriton; the grey hats and breeches and stockings and red coats of the Culmstock; the cream-collared bright blue coats

and stockings and cream breeches of the Crowhurst from Surrey, Kent, and Sussex; men of the Dartmoor, all in navy-blue, from pad-pinned cap to black brogues, except for white stock round the throat; the green double-peaked caps, green coats, scarlet ties, white breeches, and green stockings of the Courtenay Tracey from Wessex. A man like a great seal, jovial and gruff among laughing friends, wore the gayest uniform, in the judgment of two ragged children. It blazed and winked in the sunlight, scarlet and blue and brass.

Shortly after half-past ten o'clock eleven and a half couples of hounds and two terriers, nearly throttling themselves in eagerness to press forward, were trotting behind the huntsman through the farmyard to the river. The huntsman repeated a cooing chant at the back of his nose of *C-o-o-o-orn-yer! C-o-o-o-orn-yer! W-wor! W-wor!* with names of hounds. They trotted with waving sterns, orderly and happy, enjoying the sounds, which to them were promise of sport and fun if only they kept together and ignored the scent of duck, cat, offal, mouse, and cottage-infant's jammy crust. They pattered through the farmyard in best behaviour; they loved the huntsman, who fed them and pulled thorns out of their feet and never whipped them, although he sometimes dropped unpleasant medicine at the back of their tongues, and held their muzzles, and stroked their throats until they could hold it there no longer, but had to swallow. The *W-wor! W-wor!* and other cooing dog-talk was understood perfectly; they caused even Deadlock to forget to growl when young Dabster, avoiding a kitten, bumped into him. For the two strongest feelings in Deadlock, apart from those of his private kennel life, were blood-thirst for otters and his regard for the huntsman.

Henry Williamson
Tarka the Otter
G.P. PUTNAM'S SONS
1928

War Dogs

LIEUTENANT COLONEL EDWIN HAUTENVILLE RICHARDSON
*founded and ran the British War Dog School at Shoeburyness, Essex,
during the First World War. Dogs trained to take messages to and from
the front line not only saved lives by delivering vital information, but also
were sometimes the only effective way of communicating. In daylight, the
average speed of a messenger dog was one-half to one-third that of a human
envoy, and even less than that at night. Dogs were also less likely to get lost
and forfeit valuable time. These extracts reveal the careful consideration
that goes into training dogs to such a high standard, and Richardson's
intuitive understanding that kind handling and patience achieve so much
more in training than coercion, aggression and punishment.*

The heavy bombardments which are a feature of modern warfare render communication with the front line exceedingly difficult to maintain. The object of the use of messenger dogs, therefore, is:

To save human life.

To accelerate dispatch-carrying.

Telephones soon become useless, and the danger to the human runner is enormous. Added to the difficulties are the shell-holes, the mud, the smoke and gas, and darkness. It is here that the messenger dog is of the greatest assistance. The broken surface of the ground is of small moment to it, as it lightly leaps from point to point. It comes to its duty in the field well broken to shell-fire, and so has no fear. Its sense of direction is as certain at night as in the day, and equally so in mist or fog. Being a smaller and more rapidly-moving object, the danger of its being hit is much less than in the case of a runner, and it is a fact that during the war casualties were extraordinarily low among the messenger dogs, especially when it is taken into consideration that their work was always in the hottest of the fight. There is a most remarkable record of the tenacity and courage with which the dogs did their work in the face of every kind of difficulty. There have been many occasions when a situation, at one moment so full of anxiety and uncertainty, has been completely transformed by the arrival, out of the chaos and darkness, of one of these brave dogs bearing its message of information and appeal.

Now it must here be observed why the training of the messenger differs from that of any other dog. In the first place, the dog has to work entirely on its own initiative, and may be miles away from its keeper. It has to know what it has to do, and how to think out how best to do it. The only training that approaches it is that of the shepherd's dog, where a man may send his dog up the hill-side with directions to gather in the sheep. But the distance is not so great, nor are the difficulties to be encountered to be compared. It is easy to understand, therefore, that the messenger dog has to be trained in such a way that it takes keenest delight and pride in its work. The highest qualities of mind – love and duty – have to be appealed to and cultivated. Coercion is of no avail, for of what use would this be when the dog is two or three miles away from its keeper? In fact, it may be said that the whole training is based on appeal. To this end the dog is gently taught to associate everything pleasant with its working hours. Under no circumstances whatever must it be roughly handled or roughly spoken to. If it makes a mistake, or is slack in its work when being trained, it is never chastised, but is merely shown how to do it over again. If any of the men under instruction are observed to display roughness or lack of sympathy with the dogs, they should be instantly dismissed, as a promising young dog could easily be thrown back in his training, or even spoiled altogether, by sharp handling. ...

The training of the messenger dog requires a decidedly special gift in the instructor. Without a long, intimate, and practical working experience among dogs on a large scale, no one need attempt to train messenger dogs in war-time. It must be understood that training includes the instruction of the men who are to act as keepers to the dogs, as well as of the dogs themselves.

In organizing the school in the first place, I recommended that gamekeepers, shepherds, and hunt servants should be especially asked for, and this may be said to be a fair working basis on which to start, but my experience goes to show that many of the men who had actually worked among dogs all their lives were not necessarily the best for this particular branch. In order to be a good keeper for a messenger dog in the field, a man must in the first place be brave, and he must be fit. He is no use if he is afraid of the front line, or if he is incapacitated. In fact, he should be an A1 man. The men comprising the personnel require to be of an honest, conscientious character, with sympathetic understanding for animals. A keeper, when in the front line, though governed by definite regulations, requires to use his own initiative to a great extent in handling his dogs, and men of intelligence and faithfulness to duty are absolutely essential. It will thus be seen that a really high

standard of character is of first importance. This must be accompanied by a fondness for, and a gentleness with, dogs. Complete confidence and affection must exist between dogs and keeper, and the man whose only idea of control is by coercion and fear is quite useless. I have found that many men, who are supposedly dog experts, are not sufficiently sympathetic, and are apt to regard the dog too much as a machine. They do not study the psychology of their charges sufficiently. Another type of man to avoid is one who has trained or bred a few dogs, and thinks in consequence that he knows all there is to know. This unteachable attitude disqualifies a man at the outset. Some of the most successful keepers, that is to say, those who obtained the best results from the dogs in the field, and were also the most helpful when under instruction at the school, were those who, having a natural love of animals, had had no previous experience of a particular nature with dogs.

Now the most important point in the whole messenger service is the question of the keepers. It is more important than that of the dog. The cleverest dog is nonplussed in charge of a stupid or unconscientious keeper. ... The training of messenger and guard dogs is so different from every other kind of dog work that practically anything that a man has learned before about dogs has to be forgotten before he is qualified to be trained himself, and to train others. Added to this, the fact of managing several hundred dogs is a new lesson to learn in itself. ...

In analysing the capabilities of the breeds ... for message-carrying, experience goes to show that ... fox terriers, besides being too small, are too fond of play, and do not take work seriously. It must be admitted, however, that many of our best dogs were Irish terriers and Welsh terriers. These little fellows were remarkably easily taught, and were tremendously keen on their work. Retrievers, unless they have a strong cross of collie or sheep dog in them, may be ruled out. They were very seldom entirely satisfactory. I put that down to the use of this breed for sport. Under that system of training the dog does his work always more or less under his keeper's control, within sound of his voice, and the habit of independent thinking, which has to be incul- cated in the messenger dog, is therefore difficult to instil. The sheep dogs, and by this I mean the shaggy or Highland variety, frequently make good dogs. They are sometimes rather highly strung, and for that reason their training takes longer and requires great

patience, but if one can overcome their tendency to nervousness, they are naturally extremely intelligent and conscientious workers. ...

In the early days of the dog's training, it is not asked to travel very long distances, but before it is considered ready for the field it must have been in the regular habit of carrying messages over different sorts of country for three and a half to four miles. The ground over which the dogs are trained must be varied as much as possible. They must be taught to travel along high roads, amongst lorry and other traffic, through villages, and past every sort of camp and cook-house temptation. They must be taught not to be afraid of water, or of any inequalities in the ground. To aid the dogs in overcoming all these difficulties, all sorts of artificial obstacles are introduced into the route of the dog's journey over and above those he would meet in the ordinary way. Barbed wire entanglements, palings, fences, water dykes, smoke clouds, made by harmless means, etc., should intercept its homeward journey, and it must be induced at all costs, one way or another, to surmount these difficulties by going over, through, or under. It is left to the dog to choose, but come he must. ...

[Apart from the training,] the intense desire to reach a given place impels the dog forward; ... as it yields to this impulse, ... a certain guiding sense, which is in itself quite independent of any assistance from external phenomena, comes to its aid, and the sense of direction is, *in* this very sense – that the dog desires to be there, and *follows this desire*, rather than troubling about the aspect of the surroundings in getting there. The more it becomes accustomed to throw all its effort into this intuitive prompting, the more it discards any temporary assistance it may be tempted to use, in the first place, such as noting turns in the road, and other external aids, and also the more it improves in its way-finding duties. The deduction, in fact, seems to be plain, that the desire itself brings its own lesson, and a world of intelligence is opened up to the dog, and to all animals, under stress of this governing force, of which we human beings are quite unconscious, because we have not yet exercised this particular mental effort along the same lines as the animals ... [T]hose promptings which have their origin in what we call instinct, are due to an intelligence quite apart from, and infinitely above, any guidance from the senses.

Lt.-Colonel E.H. Richardson
British War Dogs
SKEFFINGTON & SON LTD
1920

Police Dogs

*This fascinating extract by the highly successful dog
trainer* JAY RAPP *(died 1997) opens a window on to a world most of us
probably rarely think about. The police are often criticized for the way
they deal with situations – but how many people ever really imagine what
their work is like? Rapp's writing has a gripping immediacy and practical
focus, and speaks with the pragmatic authority that comes of years spent
training police department canine units.*

Nobody knows better than a police officer how frightening it is to check out a building after finding a door open. You do not know if somebody is in the building or not. You know there are thousands of places to hide. You feel like a target when you walk around carrying a bright flashlight. What a relief it is to say, 'Let the dog check it.' From that point on, a member of the canine unit takes over. He and his dog enter the building and the dog finds the suspect without making the police officer the target and without permitting a possibility that an intruder could be overlooked because of his hiding place.

What about prowler-calls in a residential neighborhood? Who wants to climb over fences and walk through the yards at night looking for a suspect? Who wants to walk through vacant lots with grass above the knees looking for someone who is on drugs and carrying a shotgun? Who wants to search a four-story department store, room by room? The answer to all the questions is the canine team. The dog loves his work and the police handler loves working with his dog. As a team they are unbeatable.

The dog's ability to detect and distinguish between odors is hundreds of times greater than man's. The dog's ability to see movement is unquestionably better than man's. With proper training these senses can be used to aid the police officer and in some cases even save his life.

Let's look at the other side of the police canine unit – public relations and the deterring of crime. As a public relations tool, the dogs will bring more good publicity to a department than any other single unit. Canine officers will visit civic and church groups and explain how the dogs are used and show how friendly the dogs are. They will educate the community to the fact that the dogs are not dangerous; that the dogs live in their homes and play with their children; that the dogs will not attack unless commanded; and that the dogs will save the taxpayers money by making it unnecessary for a second officer to ride along when a police officer has a dog. Dogs do not go out on strike. Dogs do not require a minimum wage. They are happy employees as long as they are fed, cared for, and allowed to work.

I do not know of any single tool more effective for deterring crime than the dog. The presence of a dog during large public gatherings keeps the people from getting out of hand. The dog walking the beat keeps purse snatchers away from the area. The night patrol of canine unit officers around warehouses keeps burglars from the area. And just the general psychological effect of a city having dogs makes a criminal think twice before committing a crime in that city.

Your city attorney will probably confirm that no special insurance is needed to cover dog bites, and that the only additional laws that might be needed are laws to protect the dog from harm and not to protect the citizens from the dogs.

Jay Rapp
How to Train Dogs for Police Work
DENLINGER'S PUBLISHERS LTD
1979

The Outside Dog

*Most readers will be familiar with lighter samples of the
work of* ALAN BENNETT *(born 1934) than the one included here.
While it features many of Bennett's most significant and successful
trademarks – wonderful, pithy one-liners that ring utterly true to the
character speaking them; quietly brilliant detail that quickly builds up
a realistic, shrewdly humorous yet poignant picture; and, above all,
characters who are trapped in limited circumstances and muted desolation
– this time, Bennett focuses unflinchingly on the horror that may subsist
within the mundane. It is a tour de force. Rarely has the presence of a
dog, in this case apparently a menace, but in fact a trusting, innocent
and key witness tragically and catastrophically lacking the power
to tell what it knows, been so adroitly and darkly deployed.*

'd be the same if it was a cat. Because they make as much mess as dogs. Only cats you can be allergic to, so people make allowances. And flowers, of course, some people. Only we don't have flowers. Well, we do but they're all washable. I just think it spies on me, that tongue lolling out.

He took the van over to Rawdon last night. Said it was Rawdon anyway. Doing something or other, fly-tipping probably. Takes Tina which was a relief from the woof-woofing plus it gave me a chance to swill.

I'd had Mrs Catchpole opposite banging on the door in the afternoon saying she was going to the council because it wanted putting down. I said, 'I agree.' She said, 'I'm getting a petition up.' I said, 'Well, when you do, fetch it across because I'll be the first signatory.' I hate the flaming dog. Of course she doesn't do it with him. Never makes a muff when he's around.

He comes in after midnight, puts his clothes in the washer. I said to him last week, 'Why don't you do your washing at a cultivated hour?' He said, 'You're lucky I do it at all.' Still, at least the washer's in the shed. I shouted down, 'That dog's not inside is she?' He said, 'No. Get to sleep.' Which I was doing only when he comes up he has nothing on. He leaves it a bit then slides over to my side and starts carrying on.

Found a dog hair or two on the carpet this morning so that meant another shampooing job. I only did it last week. This shampoo's got air-freshener in, plus a disinfectant apparently.

Non-stop down at the yard since they started killing off the cows, so when he comes in this dinner-time he wants to eat straight off. Swills his boots under the outside tap and he's coming in like that. I said, 'Stuart. You know the rules. Take them off.' He said, ' There's no time.' So I said, 'Well, if there's not time you'll have it on the step.' Sits there eating and feeding Tina. She licks his boots. Literally. I suppose it's with him coming straight from the slaughterhouse.

Seems to have lost another anorak, this one fur-lined.

FADE

She comes up this afternoon, his mother, all dolled up. Says, 'You've got this place nice. How do you manage with our Stuart?' I said, 'I've got him trained.' She said 'He's not trained when he comes down our house.' 'Well,' I said, 'perhaps he doesn't get the encouragement.' She said, 'I don't like it when they're too tidy. It's not natural.'

Not natural at their house. They've no culture at all. First time I went down there they were having their dinner and there was a pan stuck on the table. When it comes to evolution they're scarcely above pig-sty level. And she must be sixty, still dyes her hair, fag in her mouth, big ear-rings. She said, 'You don't mind if I smoke? Or do you want me to sit on the step?'

I gave her a saucer only it didn't do much good, ash all over the shop. She does it on purpose. It had gone five, she said, 'Where is he?' I said, 'Where he generally is at this time of day: slitting some defenceless creature's throat. They're on overtime.'

She went before it got dark. Said she was nervous what with this feller on the loose. Made a fuss of Tina. Remembered her when she was a puppy running round their house. I remember it an' all. Doing its business all up and down, the place stank. It was me that trained Stuart. Me that trained the dog.

Except for the din. Can't train that. Leaves off, of course when he appears. He doesn't believe she does it. I said to him, 'Is it safe for me to go on to the library?' He said, 'Why?' I said, 'There's a lass dead in Wakefield now.' He said, 'You don't cross any waste ground. Take Tina.'

Anyway I didn't go and when he's changed out of his muck and swilled everything off he put on his navy shirt, little chain round his neck and the tan

slacks we bought him in Marbella. I brought him a beer in a glass while I had a sherry. Him sat on one side of the fire, me on the other, watching TV with the sound down. I said, 'This is a nice civilised evening.'

Except of course madam gets wind of the fact that we're having a nice time and starts whimpering and whatnot and jumping up outside the window and carries on and carries on until he has to take her out. Gone two hours so I was in bed when he got back.

Comes upstairs without his trousers on. I said, 'What've you done with your slacks?' He said, 'The dog jumped up and got mud on. Anyway it's quite handy isn't it?' I said, 'Why?' He said, 'Why do you think? Move up.'

Lots of shouting and whatnot. I thought in the middle of it, it's a blessing we're detached. 'Sorry about that,' he said when he'd done. 'I get carried away.'

Loudspeaker van came round this afternoon saying the police were going to be coming round. House to house. I was just getting some stuff ready to take to the dry cleaners while it was light still.

Couldn't find his slacks.

FADE

She said, ' Have you any suspicions of anyone in your family?' I said, 'What family? There's only me and him.' He said, 'We can't talk with this dog carrying on. Can't we come inside?' I said, 'You've told people not to open their doors.' She said, 'But we're the police.' I said, 'Well, take your shoes off.'

She's in uniform, he's got a raincoat on. She said, 'We've had complaints about the dog. It's in your print-out.' I said, 'Oh it's the dog, is it? I thought it was the killer you were after.' She said, 'Your hubby says it never barks.' I said, 'When did you talk to him?' She said, 'At his place of employment. These are the dates of the murders. Look at them and tell me whether you can remember where your husband was on any of these dates.' I said, 'He was at home. He's always at home.' She said, 'Our information is he'll sometimes go out.' I said, 'Yes. With the dog. Do you know dogs? They occasionally want to have a jimmy riddle.' She said, 'What about this fly-tipping? His van's been seen.' I said, 'The van's not my province. Though I've shared the back seat with a beast head before now.'

Meanwhile the one in the raincoat's been sitting there saying nothing, looking round, sizing the place up. Suddenly he stands up. 'Can I use the toilet?' I said, 'Now? Well, you'll have to wait while I put a paper down.'

I took him upstairs and waited outside. He says, 'I can't do it with you listening.' So I came downstairs again. And she says, 'He's got a funny bladder.'

'One last question. Have you noticed anything out of the ordinary about your husband stroke boy friend stroke father stroke son ... well, that's husband in your case ... over the last six months?' 'Like what?' 'Blood on his clothes?' I said, 'There's always blood. He's a slaughterman. Only you won't find any in here. And you won't find any outside. He swills it off.' I said, 'Your friend's taking his time.' She said, 'Men have problems with their water. I've an idea he has an appliance.'

When eventually he comes down he says, 'You keep the place tidy.' I said, 'I used to be a teacher.' He said, 'What did you teach?' I said, 'Children.' He said, 'Do you have any?' I said, 'Does it look like it?'

As they're going Mother Catchpole opposite is stood in the road and shouts across, 'I've got something to tell you.' So the girl goes over and has a word. Comes back. 'Nothing,' she says. 'Just the flaming dog.' 'Nobody listens to me,' she's shouting, 'I've had depression with that dog.'

I shut the door. When I went upstairs to wipe round the toilet I saw he'd moved one or two ornaments. Nothing else that I could see.

When his lordship came in I said, 'You never told me they'd been to your work.' He said, 'It was routine. I've tipped on one of the sites where they found one of them.' I said, 'Did you find that ticket?' He said, 'What ticket?' 'For the dry cleaners. The tan slacks.' He said, 'Oh yes. They're at work.' I said, 'You're not wearing them for work. They're good slacks are them.' He said, 'They're shit-coloured. What do I want with shit-coloured trousers?'

He was in the yard swilling his boots when he was saying all this. Outside. He's started being much more careful about all that. I don't know what's got into him.

FADE

Lad opposite just delivering four pizzas to No. 17. She's a widow, living on her own with a son in New Zealand and a heart condition, what's she wanting with four pizzas? I bet she's never had a pizza in her life. They must think I'm stupid. The doctor said, 'Why can't you sleep?' I said, 'The police are bugging my home.' She said, 'Yes. There's a lot of it about.' Asian too. They're normally a bit more civil.

We went out in the van the other night and he stopped it somewhere and said, 'Do you think it's me?' I said, 'No.' He said, 'Well, my mam does. It was her that went to the police.' 'And what did they say?' 'Told her she wasn't the only one.

Mothers queuing up apparently.' I said, 'Well, she might cut a bit more ice if she didn't wear that leopard-skin coat thing. Legacy from when she was at it herself.' 'At what?' 'Soliciting.' He said, 'Who told you that?' I said, 'You did. You said she was hard up.' He said, 'It was years ago. I was still at school.'

Went out with Tina later on and comes in all worked up again. Sets to. Thought he was going to go through the bed. And saying stuff out loud again. I thought of them across the road, listening, so I put my hand over his mouth at one point, which he seemed to like.

I waited to see if there was anything in the papers only there wasn't. Been nothing for about a week now. You can get things out of proportion, I think.

I found where they'd put their listening thing this morning. Little hole in the skirting board. Did it when he was reckoning to go to the lavatory. Must have been quick because he'd managed to colour it white so it didn't show only some fluff got stuck to the paint so that's how I spotted it.

Sound of a newspaper coming through the door. She picks it up.

They've found another one, it looks like. This time on a skip. Been there ... about a week.

FADE

One of them leaps over the wall, quite unnecessarily in my opinion because the gate's wide open. They get it off the TV. Five police cars. Batter on the door and when he opens it bowl him over and put handcuffs on him and take him off with a jacket over his head.

Tina, of course is going mad and they've got a dog of their own which doesn't help. I said, 'You're not fetching that thing in here.' He said, 'We've got a warrant.' I said, 'His dog's not been in here so I don't see why your dog should.' He said, 'This is an instrument of law enforcement.' I said, 'Yes, and it's an instrument of urinating against lampposts and leaving parcels on pavements. I don't want it sniffing round my stuff.' He says, 'You've got no choice, love,' and shoves me out of the way.

One of them's upstairs going through the airing cupboard. I said, 'What are you looking for? Maybe I can help?' He said, 'If you must know we're looking for the murder weapon.' I said, 'Oh, I can show you that. This is the murder weapon

(Points to her tongue). This is always the murder weapon. You want to drag the canal for that.'

He said, 'You sound sicker than he does. I don't think you realise the seriousness of your situation. If we find you know what's been going on you'll be in the dock yourself.' I said, 'Don't put those sheets back. I shall have them all to wash now you've been handling them.' He said, 'We shall want all his clothes and other selected items,' and produces a roll of bin bags. 'Is everything here? He hasn't got anything at the dry cleaners?' I said, 'No.' I said, 'How do I know we'll get all this stuff back?' He said, 'That's the least of your worries.'

When eventually they go the handler reckons to take charge of Tina, except that he can't get her to go in the car with them. Then when they do force her in they all pile out sharpish because she's straightaway done her business in the car. I laughed.

It was suddenly quiet when they'd gone, just Mother Catchpole at her gate shouting. 'The doctor says I'm clinically depressed. That dog wants putting down.'

The police said not to touch anything but I wasn't having the place left upset like that so I set to and cleaned down and repaired the ravages a bit. One or two folks outside the house looking in and the phone rings now and again but I don't answer.

Dark by the time I'd finished but I didn't turn the lights on, just sat there. They must have charged him around six because suddenly there's cars drawing up and the phone's going like mad and reporters banging on the door and shouting through the letter-box and whatnot.

I just sit there in the dark and don't take on.

FADE

Another parcel of excrement through the letter-box this morning. Postmarked Selby. Pleasant place. We had a little run there once in the van. Saw the cathedral, abbey, whatever it is. Shop with booklets and teatowels the way they do. Had a cup of coffee at a café down a street. The postman whanged it through that hard it split on the doormat.

It's probably deliberate. I'd got some plastic down from the previous times but still I'd to set to again. Spend a fortune on Dettol.

The trial's in Manchester for some reason. Out of the area. They can't call me unless I choose. Which I don't. Woman spat at me in Sainsbury's so I shop at the Asian shops now. Everywhere else they stare. Have to go thirty miles to get a perm. Go by minicab. Asians again. Never liked them much before. Don't ask questions. Godsend.

Reporter comes ringing the doorbell this afternoon. I think they must take it in turns. Shouts through the letter-box. I said, 'You want to be careful with that letter-box. You don't know what's been through it.' Says I'm sitting on a gold mine. Talks about £10,000. My side of the story.

Final speeches today. It rests on the dog, apparently, the rest is circumstantial. The van seen where the murders were, stopped once even but nothing else. Nothing on his tools. Nothing on his clothes. Only they found some blood belonging to the last one on the dog. The defence says it could have rolled in the blood because with the dog being fastened up all day when they went off he let it roam all over. So it doesn't mean he was with her, or anywhere near as the dog was off the lead.

The judge likes dogs. Has a dog of his own apparently. I don't know that'll make any difference.

I saw him before the trial started. Looked thinner. I was disappointed not to see him wearing a tie. I thought a tie would have made a good impression only they use them to commit suicide apparently.

I wish I'd something to do. I've cleaned down twice already. The yard wants doing only I can't do it with folks and reporters hanging about.

Pause.

He's lying, of course. Our Tina hasn't been seen to, so when he takes her out he never lets her off the lead. Ever.

<div align="center">FADE</div>

'Marjory! Marjory!'

They still shout over the gate now and again, one of them there this morning. Most of them have gone only they leave a couple of young ones here just in case I go shopping. Jury's been out two days now and they think it might be a week.

Anyway I thought while the heat was off I might be able to sneak out into the yard and give the kennel a good going over. The forensics took away her blanket so that's a blessing. I said to the feller, 'Don't bother to fetch it back. I'd have wuthered it long since if he'd let me.'

I peeped out of the gate to see if it's safe to swill and there's just a couple of the young reporters sat on Mrs C's doorstep having a cup of tea. I don't know what she's going to do when it's all over. She's had the time of her life.

Anyway I chucked a bucket of water under the kennel and then another only it didn't seem to be coming out the other side. I thought it was muck that had built up or something so I went in and got a wire coat hanger and started scraping about underneath and there's something there.

It was his tan slacks, all mucky and plastered up with something. I sneaked in and got a bin bag and fetched them inside.

Thinking back the police had been round with the dog but I suppose it couldn't smell anything except Tina. I sit there staring at this bag wondering whether there's anybody I should ring up. Suddenly there's a banging at the door and a voice through the letter-box.

'Marjory! Marjory!'

I didn't listen I ran with the bag and put it in the cupboard under the stairs. More clattering at the door.

'Marjory! Marjory! They've come back, the jury. He's been acquitted. He's got off. Can we have a picture?'

FADE

The young woman says, 'Did I want any assistance with costume or styling? There'll be a lot of photographers.' I said, 'What's the matter with what I've got on?' She said, ' I could arrange for someone to come round and give you a shampoo and set.' I said, 'Yes, I could arrange for someone to come round and give you a kick up the arse.'

Though come to think of it I couldn't actually. She said, 'The paper's got a lot of money invested in you.' I said, 'Well, that's your funeral.'

Picture of him and the dog on the front page this morning, dog licking his face, ears up, paws on his shoulder, loving every minute of it. Spent the night in a hotel, five star, paid for by the newspaper. Article 'These nightmare months.' I stood by him, apparently. Says the longed-for reunion with his wife Marjory is scheduled for sometime this afternoon.

Police furious. The inspector in charge of the investigation said, 'Put it this way. We are not looking for anybody else.'

Sat waiting all afternoon. Photographers standing on the wall opposite, and on chairs and kitchen stools, two of them on top of a car. One up a tree. Police keeping the crowds back.

Getting dark when a big car draws up. Pandemonium.

Policeman bangs on the door, and Stuart's stood there on the doorstep and all the cameras going and them shouting, 'Stuart, Marjory. Over here. Over here please.' They want pictures of us with the dog, only the fellow from the newspaper says, No. They're going to be exclusive, apparently.

I said, 'Well, I've washed her kennel.' He says, 'She's not staying in there.' I said, 'You're not fetching her inside.' He said, 'I bloody am.' I said, 'Well, she'll have to stay on her paper.'

Later on when we're going to bed I wanted to shut her downstairs in the kitchen but he wouldn't have that either, keeps kissing her and whatnot and says she has to come upstairs.

When we're in bed he starts on straightaway and keeps asking Tina if she's taking it all in.

Afterwards he said, 'Are you surprised I'm not guilty?' I said, 'I'm surprised you got off.' He said, 'Don't you think I'm not guilty?' I said, 'I don't know, do I?' He said, 'You bloody do. You'd better bloody know. You're as bad as my mam.' I said, 'I'm not your mam.' He said, 'No, you're bloody not' and laughs.

I must have fallen asleep because when I wake up he's sleeping and the dog's off its paper, sat on his side of the bed and watching him.

I get up and go downstairs and get the bin bag from under the stairs only I don't put any lights on. Then I get the poker and go out into the yard and push the slacks back under the kennel.

It's a bit moonlight and when I look over the gate they've all gone, just a broken chair on the pavement opposite.

I get back into bed and in a bit he wakes up and he has another go.

FADE

Alan Bennett
Talking Heads 2
BBC WORLDWIDE LTD
1998

Something

*This marvellously macabre conjuration of a wraith-like
creature 'much like a hound' is part of the award-winning collection*
Legion *(2005) by* DAVID HARSENT *(born 1942), which includes many
poems about an unspecified war, seen in all its horror and pathos from
various points of view. In mythology and folklore, dogs have long
been associated with death, and in creating this sinister creature,
scurrying past with something torn from a carcass in its maw,
the poet skilfully exploits that connection.*

Something going through, something much like a hound
or wolf, in the hour *entre chien et loup*, the blue
hour when birdsong stops, just for a minute or two,
and the dead in the graveyard shuffle up the queue.

Something lean and low-slung, its muzzle to the ground,
something leaving a drip-trail of blood or piss.
It has come by way of the rift and the pretty pass,
slipping between the dead cert and the near-miss.

Something that whines and whimpers, much like the sound
of a child in pain, or love's last gasp. It shows
a backbone like a hat-rack, an eye like a bruise,
in its mouth, a rib (is it?), dark meat, the pope's nose.

David Harsent
'Street Scenes', (v), from *Legion*
FABER AND FABER
2005

The Hound of the Baskervilles

SIR ARTHUR CONAN DOYLE *(1859–1930) is
so famous as scarcely to need an introduction. His book*
The Hound of the Baskervilles *(1901–1902) is one of those works
that, read and reread down the decades, becomes part of the collective
consciousness, and in so doing, takes on a power and life of its own, as
strange and compelling as the magnificently sinister hound at its heart,
which, coal-black and breathing fire, bursts unforgettably from the fog. In
creating it, Conan Doyle drew on ancient folklore – tales of mysterious black
dogs, usually presaging death, abound throughout the world – but also, very
probably, on deep preoccupations within himself. He was fascinated by
Spiritualism and the paranormal all his life; and his father lost his mind.
These currents, and the desire to get to the bottom of them, swirl
beneath the surface of this murderously brilliant story.*

I have said that over the great Grimpen Mire there hung a dense, white fog. It was drifting slowly in our direction and banked itself up like a wall on that side of us, low, but thick and well-defined. The moon shone on it, and it looked like a great shimmering ice-field, with the heads of the distant tors as rocks borne upon its surface. Holmes's face was turned towards it, and he muttered impatiently as he watched its sluggish drift.

'It's moving towards us, Watson.'

'Is that serious?'

'Very serious, indeed – the one thing upon earth which could have disarranged my plans. He can't be very long now. It is already ten o'clock. Our success and even his life may depend upon his coming out before the fog is over the path.'

The night was clear and fine above us. The stars shone cold and bright, while a half-moon bathed the whole scene in a soft, uncertain light. Before us lay the dark bulk of the house, its serrated roof and bristling chimneys hard outlined against the silver-spangled sky. Broad bars of golden light from the lower windows stretched across the orchard and the moor. One of them was suddenly shut off. The servants left the kitchen. There only remained the lamp in the dining-room where

the two men, the murderous host and the unconscious guest, still chatted over their cigars.

Every minute that white woolly plain which covered one half of the moor was drifting closer and closer to the house. Already the first thin wisps of it were curling across the golden square of the lighted window. The farther wall of the orchard was already invisible, and the trees were standing out of a swirl of white vapour. As we watched it the fog-wreaths came crawling round both corners of the house and rolled slowly into one dense bank, on which the upper floor and the roof floated like a strange ship upon a shadowy sea. Holmes struck his hand passionately upon the rock in front of us, and stamped his feet in his impatience.

'If he isn't out in a quarter of an hour the path will be covered. In half an hour we won't be able to see our hands in front of us.'

'Shall we move farther back upon higher ground?'

'Yes, I think it would be as well.'

So as the fog-bank flowed onwards we fell back before it until we were half a mile from the house, and still that dense white sea, with the moon silvering its upper edge, swept slowly and inexorably on.

'We are going too far,' said Holmes. 'We dare not take the chance of his being overtaken before he can reach us. At all costs we must hold our ground where we are.' He dropped on his knees and clapped his ear to the ground. 'Thank God, I think that I hear him coming.'

A sound of quick steps broke the silence of the moor. Crouching among the stones, we stared intently at the silver-tipped bank in front of us. The steps grew louder, and through the fog, as through a curtain, there stepped the man whom we were awaiting. He looked round him in surprise as he emerged into the clear, star-lit night. Then he came swiftly along the path, passed close to where we lay, and went on up the long slope behind us. As he walked he glanced continually over either shoulder, like a man who is ill at ease.

'Hist!' cried Holmes, and I heard the sharp click of a cocking pistol. 'Look out! It's coming!'

There was a thin, crisp, continuous patter from somewhere in the heart of that crawling bank. The cloud was within fifty yards of where we lay, and we glared at

it, all three, uncertain what horror was about to break from the heart of it. I was at Holmes's elbow, and I glanced for an instant at his face. It was pale and exultant, his eyes shining brightly in the moonlight. But suddenly they started forward in a rigid, fixed stare, and his lips parted in amazement. At the same instant Lestrade gave a yell of terror and threw himself face downwards upon the ground. I sprang to my feet, my inert hand grasping my pistol, my mind paralysed by the dreadful shape which had sprung out upon us from the shadows of the fog. A hound it was, an enormous coal-black hound, but not such a hound as mortal eyes have ever seen. Fire burst from its open mouth, its eyes glowed with a smouldering glare, its muzzle and hackles and dewlap were outlined in flickering flame. Never in the delirious dream of a disordered brain could anything more savage, more appalling, more hellish, be conceived than that dark form and savage face which broke upon us out of the wall of fog.

With long bounds the huge black creature was leaping down the track, following hard upon the footsteps of our friend. So paralysed were we by the apparition that we allowed him to pass before we had recovered our nerve. Then Holmes and I both fired together, and the creature gave a hideous howl, which showed that one at least had hit him. He did not pause, however, but bounded onwards. Far away on the path we saw Sir Henry looking back, his face white in the moonlight, his hands raised in horror, glaring helplessly at the frightful thing which was hunting him down.

But that cry of pain from the hound had blown all our fears to the winds. If he was vulnerable he was mortal, and if we could wound him we could kill him. Never have I seen a man run as Holmes ran that night. I am reckoned fleet of foot, but he outpaced me as much as I outpaced the little professional. In front of us as we flew up the track we heard scream after scream from Sir Henry and the deep roar of the hound. I was in time to see the beast spring upon its

victim, hurl him to the ground and worry at his throat. But the next instant Holmes had emptied five barrels of his revolver into the creature's flank. With a last howl of agony and a vicious snap in the air it rolled upon its back, four feet pawing furiously, and then fell limp upon its side. I stooped, panting, and pressed my pistol to the dreadful, shimmering head, but it was useless to pull the trigger. The giant hound was dead.

Sir Henry lay insensible where he had fallen. We tore away his collar, and Holmes breathed a prayer of gratitude when we saw that there was no sign of a wound and that the rescue had been in time. Already our friend's eyelids shivered and he made a feeble effort to move. Lestrade thrust his brandy-flask between the Baronet's teeth, and two frightened eyes were looking up at us.

'My God!' he whispered. 'What was it? What, in Heaven's name, was it?'

'It's dead, whatever it is,' said Holmes. 'We've laid the family ghost once and for ever.'

In mere size and strength it was a terrible creature which was lying stretched before us. It was not a pure bloodhound and it was not a pure mastiff; but it appeared to be a combination of the two – gaunt, savage, and as large as a small lioness. Even now, in the stillness of death, the huge jaws seemed to be dripping with a bluish flame, and the small, deep-set, cruel eyes were ringed with fire. I placed my hand upon the glowing muzzle, and as I held them up my own fingers smouldered and gleamed in the darkness.

'Phosphorus,' I said.

Arthur Conan Doyle
The Hound of the Baskervilles
OXFORD UNIVERSITY PRESS
1993

The Company of Wolves

ANGELA CARTER *(1940–1992) was a truly original
and remarkable writer. Her imagination was colourful, ferocious
and daring, and conveyed in prose that is lush, fluent, grandiose and
dripping with ornament – almost tangible in its power. As such, it is
ideally suited to the evocation of the savagery and sensuous beauty of
animals. Fur, scent and skin – or, as in this extract, 'a taste of flesh',
'your smell of meat' – are lingeringly described. But Carter did not
favour realism – quite the opposite. She was interested in transformation,
and her characters often literally shape-shift and become beasts, and vice
versa. It is as if Carter never lost the simple pleasure many children enjoy
in pretending to be animals, with all the freedom from conventional
behaviour, and the heady sense of acceding to other powers, that
this affords. 'The Company of Wolves' (1979) is one of
three stories she wrote about werewolves.*

One beast and only one howls in the woods by night.

The wolf is carnivore incarnate and he's as cunning as he is ferocious; once he's had a taste of flesh then nothing else will do.

At night, the eyes of wolves shine like candle flames, yellowish, reddish, but that is because the pupils of their eyes fatten on darkness and catch the light from your lantern to flash it back to you – red for danger; if a wolf's eyes reflect only moonlight, then they gleam a cold and unnatural green, a mineral, a piercing colour. If the benighted traveller spies those luminous, terrible sequins stitched suddenly on the black thickets, then he knows he must run, if fear has not struck him stock-still.

But those eyes are all you will be able to glimpse of the forest assassins as they cluster invisibly round your smell of meat as you go through the wood unwisely late. They will be like shadows, they will be like wraiths, grey members of a congregation of nightmare; hark! his long, wavering howl ... an aria of fear made audible.

The wolfsong is the sound of the rending you will suffer, in itself a murdering.

It is winter and cold weather. In this region of mountain and forest, there is now nothing for the wolves to eat. Goats and sheep are locked up in the byre, the deer departed for the remaining pasturage on the southern slopes – wolves grow lean and famished. There is so little flesh on them that you could count the starveling ribs through their pelts, if they gave you time before they pounced. Those slavering jaws; the lolling tongue; the rime of saliva on the grizzled chops – of all the teeming perils of the night and the forest, ghosts, hobgoblins, ogres that grill babies upon gridirons, witches that fatten their captives in cages for cannibal tables, the wolf is worst for he cannot listen to reason.

You are always in danger in the forest, where no people are. Step between the portals of the great pines where the shaggy branches tangle about you, trapping the unwary traveller in nets as if the vegetation itself were in a plot with the wolves who live there, as though the wicked trees go fishing on behalf of their friends – step between the gateposts of the forest with the greatest trepidation and infinite precautions, for if you stray from the path for one instant, the wolves will eat you. They are grey as famine, they are as unkind as plague.

<div align="center">

Angela Carter
'The Company of Wolves', from *The Bloody Chamber*
PENGUIN
1981

</div>

Dog Voices

ROBERT FALCON SCOTT (1868–1912), *better known perhaps*
as Scott of the Antarctic, wrote the following as part of his account
of his first expedition there, The Voyage of the 'Discovery' (1905). *Like*
Angela Carter (see pp. 117–18), Scott evokes the disquieting quality of
howling, its unearthly, sorrowful music; but Scott's account, unlike
Carter's, derives not from his fecund imagination, but from lived
experience of the company of huskies on the trip. In this brief but wistful
extract, he opens a window on to the ice-bound polar wastes he
explored and, through the dogs' voices, expresses the immense
loneliness, both interior and exterior, of the journey
into the white, uncharted wilderness.

For it is on such nights that the dogs lift up their voices and join in a chant which disturbs the most restful sleepers.

What lingering instinct of bygone ages can impel them to this extraordinary custom is beyond guessing; but on these calm, clear moonlit nights, when all are coiled down placidly sleeping, one will suddenly raise his head and from the depths of his throat send forth a prolonged, dismal wail, utterly unlike any sound he can produce on ordinary occasions. As the note dies away another animal takes it up, and then another and another, until the hills re-echo with the same unutterably dreary plaint. There is no undue haste and no snapping or snarling, which makes it very evident that this is a solemn function, some sacred rite which must be performed in these circumstances. If one is sentimentally inclined, as may be forgiven on such a night, this chorus almost seems to possess the woes of the ages; as an accompaniment to the vast desolation without, it touches the lowest depths of sadness.

Robert Falcon Scott
The Voyage of the 'Discovery', Vol. I
Smith, Elder & Co.
1905

Dogfight

JOHN GRIFFITH LONDON (1876–1916), otherwise known as
Jack, was another author who, like John Masefield (see pp. 92–93),
went to sea as a very young man before becoming a writer. His life
was short and led at a fierce pace: even after he had achieved acclaim,
London led an eventful, frequently rough and restless existence involving
many travels. His appetite for danger and the raw unpredictability of life
is clear in this extract from what is probably his most famous work,
The Call of the Wild (1903). The sudden, slavering violence of dogs
when roused to fight is powerfully, if somewhat theatrically, rendered.
London seems to have identified strongly with the animals
he describes; one of his friends called him 'Wolf'.

An oath from Perrault, the resounding impact of a club upon a bony frame, and a shrill yelp of pain, heralded the breaking forth of pandemonium. The camp was suddenly discovered to be alive with skulking furry forms – starving huskies, four or five score of them, who had scented the camp from some Indian village. They had crept in while Buck and Spitz were fighting, and when the two men sprang among them with stout clubs they showed their teeth and fought back. They were crazed by the smell of the food. Perrault found one with head buried in the grub-box. His club landed heavily on the gaunt ribs, and the grub-box was capsized on the ground. On the instant a score of the famished brutes were scrambling for the bread and bacon. The clubs fell upon them unheeded. They yelped and howled under the rain of blows, but struggled none the less madly till the last crumb had been devoured.

In the meantime the astonished team-dogs had burst out of their nests only to be set upon by the fierce invaders. Never had Buck seen such dogs. It seemed as though their bones would burst through their skins. They were mere skeletons, draped loosely in draggled hides, with blazing eyes and slavered fangs. But the hunger-madness made them terrifying, irresistible. There was no opposing them. The team-dogs were swept back against the cliff at the first onset. Buck was beset by three huskies, and in a trice his head and shoulders were ripped and slashed.

The din was frightful. Billee was crying as usual. Dave and Sol-leks, dripping blood from a score of wounds, were fighting bravely side by side. Joe was snapping like a demon. Once, his teeth closed on the foreleg of a husky, and he crunched down through the bone. Pike, the malingerer, leaped upon the crippled animal, breaking its neck with a quick flash of teeth and a jerk. Buck got a frothing adversary by the throat, and was sprayed with blood when his teeth sank through the jugular. The warm taste of it in his mouth goaded him to greater fierceness. He flung himself upon another, and at the same time felt teeth sink into his own throat. It was Spitz, treacherously attacking from the side.

Perrault and François, having cleaned out their part of the camp, hurried to save their sled-dogs. The wild wave of famished beasts rolled back before them, and Buck shook himself free. But it was only for a moment. The two men were compelled to run back to save the grub; upon which the huskies returned to the attack on the team. Billee, terrified into bravery, sprang through the savage circle and fled away over the ice. Pike and Dub followed on his heels, with the rest of the team behind. As Buck drew himself together to spring after them, out of the tail of his eye he saw Spitz rush upon him with the evident intention of overthrowing him. Once off his feet and under that mass of huskies, there was no hope for him. But he braced himself to the shock of Spitz's charge, then joined the flight out on the lake.

Later, the nine team-dogs gathered together and sought shelter in the forest. Though unpursued, they were in a sorry plight. There was not one who was not wounded in four or five places, while some were wounded grievously. Dub was badly injured in a hind leg; Dolly, the last husky added to the team at Dyea, had a badly torn throat; Joe had lost an eye; while Billee, the good-natured, with an ear chewed and rent to ribbons, cried and whimpered throughout the night. At daybreak they limped warily back to camp, to find the marauders gone and the two men in bad tempers. Fully half their grub supply was gone. The huskies had chewed through the sled lashings and canvas coverings. In fact, nothing, no matter how remotely eatable, had escaped them. They had eaten a pair of Perrault's moose-hide moccasins, chunks out of the leather traces, and even two feet of lash from the end of François's whip.

Jack London
The Call of the Wild
PENGUIN
1981

Poodle Dog

This zany extract from The Adventures of Tom Sawyer *(1876)*
by MARK TWAIN – *in reality* SAMUEL LANGHORNE CLEMENS
(1835–1910) – is a good example of the way in which dogs can provide
incidental entertainment and humour in a novel. The fact that they often
live on the sidelines of our lives, busy with their own pursuits but
inadvertently caught up in ours, affords endless opportunities for such
comic mishaps as the one described here. Twain, who was an immensely
successful journalist by training, must have deliberately chosen a 'poodle
dog' as the star turn. Nimble, agile, inquisitive and, with its close-curled
hair, quite amusing to look at, the breed makes a natural wag.

Presently a vagrant poodle dog came idling along, sad at heart, lazy with the summer softness and the quiet, weary of captivity [in the church], sighing for change. He spied [Tom's] beetle; the drooping tail lifted and wagged. He surveyed the prize; walked around it; smelt at it from a safe distance; walked around it again; grew bolder, and took a closer smell; then lifted his lip, and made a gingerly snatch at it, just missing it; made another, and another; began to enjoy the diversion; subsided to his stomach with the beetle between his paws, and continued his experiments; grew weary at last, and then indifferent and absent-minded. His head nodded, and little by little his chin descended and touched the enemy, who seized it. There was a sharp yelp, a flirt of the poodle's head, and the beetle fell a couple of yards away, and lit on its back once more. The neighbouring spectators shook with a gentle inward joy, several faces went behind fans and handkerchiefs, and Tom was entirely happy. The dog looked foolish, and probably felt so; but there was resentment in his heart, too, and a craving for revenge. So he went to the beetle and began a wary attack on it again; jumping at it from every point of a circle, lighting with his fore-paws within an inch of the creature, making

even closer snatches at it with his teeth, and jerking his head till his ears flapped again. But he grew tired once more, after a while; tried to amuse himself with a fly, but found no relief; followed an ant around, with his nose close to the floor, and quickly wearied of that; yawned, sighed, forgot the beetle entirely, and sat down on it! Then there was a wild yelp of agony, and the poodle went sailing up the aisle; the yelps continued, and so did the dog; he crossed the house in front of the altar; he flew down the other aisle; he crossed before the doors; he clamoured up the home-stretch; his anguish grew with his progress, till presently he was but a woolly comet moving in its orbit with the gleam and speed of light. At last the frantic sufferer sheered from its course and sprang into its master's lap: he flung it out of the window, and the voice of distress quickly thinned away and died in the distance. ...

Tom Sawyer went home quite cheerful, thinking to himself that there was some satisfaction about divine service when there was a bit of variety in it. He had but one marring thought; he was willing that the dog should play with his pinch-bug, but he did not think it was upright in him to carry it off.

Mark Twain
The Adventures of Tom Sawyer
PAN BOOKS
1968

Christabel

The American author and cartoonist JAMES THURBER
*(1894–1961) created many appealing vignettes of dogs in words and
drawings; his first-hand experience of owning dogs is abundantly evident
in them all. This affectionate and clear-eyed portrait of his standard
poodle, Christabel, is the second of two pieces that he wrote about her.
Its description of the way that the traditional roles of dog and master
have gradually become reversed, with Thurber playing the fool
in an effort to get the dog's attention, and not the other way
about, is particularly astute, as all owners of
ageing dogs will recognize.*

My poodle was fourteen years old last May and she is still immensely above ground. She slips more easily than she used to on linoleum, makes strange sounds in her sleep, and sighs a great deal, but more as if she had figured something out than given it up. Her ears are not as sharp as they were, and she often barks at things that aren't there, and sleeps through things that are. Her eyes are not much better than mine, but since she can still smell her way around as well as ever, bumps into fewer things than I do. I have heard whispers, or maybe I just imagine I heard them, that the poodle will live to see *me* laid to rest under the apple tree. When she fell a year ago on the kitchen linoleum and sprained her right shoulder, the veterinarian gave her a couple of shots of cortisone, and she came bounding merrily home from the kennels with the high heart of a schoolgirl on vacation, insisting that our clocks were two hours slow and that it was time for dinner. Some day, long after I am gone, the people who now stop at my front door to ask their way to the Cathedral Pines will want to know if they can show their grandchildren the forty-year-old French poodle.

The poodle's kennel name was Christabel, and she is a *caniche moyen*, or medium-sized French standard poodle. Most people think of all poodles, standard or miniature or toy, black or white or brown, as French, and so did I until a few years ago when I began nosing about in dog books and dictionaries. The poodle actually gets its name from the German word '*pud(d)el*,' meaning to splash in

water, for these dogs, originally German, were used to retrieve wild ducks shot down over lakes. Legend has it that a hunting poodle would swim around all night in a lake hunting for a lost duck, which brings us to an ingenious explanation of the so-called Continental trim of the poodle, familiar to everybody and ridiculous to many. It seems that the back part of the poodle's body was clipped to give it greater agility and speed in the water, that the 'bracelets' on the front legs and the pompons or epaulettes near the hip bones were left there to prevent joints from becoming stiff after a long cold patrol of the fowling waters. The tale also tells ... that the pompon on the end of the stubby tail was put there to serve as a kind of periscope by which the hunter could follow the movements of his dog in the water! The exclamation point is mine, because it is surely the front part of the swimming dog that can be most easily detected, and I am certain that before long somebody will put forward the theory that the red ribbon found in the head hair of some poodles was originally tied there to help the duck hunter locate his circling dog.

Defence counsel for the poodle has his work cut out for him, no matter who makes up the jury he addresses – canine-haters, basset- or boxer-owners, or lapdog dowagers. The word 'poodle' itself is bad enough, but the kennel names of individual members of the breed are worse: Tiddly Winks Thistledown of White Hollow, Twinkle Toes the Third, Little Chief Thunderfoot of Creepaway, and other unlikely compounds of whipped cream and frustrated mother-love, or whatever it may be that causes this sort of thing. The poodle strain caught the fancy some years ago of Park Avenue, Broadway, and Beverly Hills, and these unions have brought about such pet home names as Chi Chi, Frou Frou, Pouf Pouf, Zsa Zsa, and for God's sake don't let me go on like this. The ornamental trim of the poodle, grimly *de rigueur* in dog shows everywhere because it is said to be the best way to exhibit the dog's coat and some of its other show points, has prejudiced people against the great duck retriever for almost five hundred years. ... Whatever the truth may be, the poodle would probably have been laughed out of town and country long ago, had it not been for the sound and attractive clip known as the Dutch trim.

The poodle has been the butt of jokes, all of them pallid as far as I can find out, from Benjamin Disraeli to John L. Lewis, and this has helped to perpetuate the libel that the most sagacious of dogs is an aimless and empty-headed comic. Most apologists, in trying to defend the poodle against this calumny, succeed in making him sound foolisher and foolisher. Very few persons have successfully transcribed the comic talents of a poodle into prose, whether typed or conversational.

Something vital and essential dies in the telling of a poodle story. It is like a dim recording of a bad W.C. Fields imitator. My poodle, I am glad to say, does not meet a gentleman caller at the door and take his hat and gloves, or play the piano for guests, or move chessmen about upon a board, or wear glasses and smoke a pipe, or lift the receiver off the phone, or spell out your name in alphabet blocks, or sing 'Madelon', or say 'Franchot Tone', or give guests their after-dinner coffee cups. She is as smart as any of her breed; indeed she has taken on a special wisdom in what some would estimate to be her seventy-fifth, others her one-hundred-and-fifth year, as human lives are measured, but she has never been trained to do card tricks, or go into dinner on a gentleman's arm, or to say 'Beowulf', or even 'Ralph'. I once tried to get her to ring an old Bermuda carriage bell I picked up years ago, but she was disdainful of this noisy waste of time, and was even more reluctant when I tried to get her to step on the rubber bulb of a 1905 automobile horn. She doesn't like unnecessary sounds; she likes quiet and tranquillity.

No, my aged water-splasher has never been taught any tricks that make dinner guests and week-end visitors alert and nervous. If you open the door of your bedroom in the morning, she is not standing there with a newspaper and a glass of orange juice. Somebody once tried to show her how to carry the mail into the house, and she gaily spread the letters all over the front lawn, a light-hearted and sensible way of dealing with my correspondence, which consists largely of invitations to address the Men's Forum of Dismal Seepage, Ohio, requests for something intimate to raffle off at a church bazaar, and peremptory demands, such as: 'My sister-in-law has ulcers. Please send her six drawings.' The poodle will shake hands, in the gracious manner of her breed, and engage in impromptu house games and lawn games, but she will not appear suddenly at your elbow at the cocktail hour carrying a plate of hors d'œuvres. She is a country dog, and trembles all over when she is driven in to New York, which isn't often, but the atavistic urge to hunt and swim must have gone out of her bloodline generations ago, leaving no trace. She couldn't tell a mallard or a canvasback from a Plymouth Rock hen, and gunfire appal's [*sic*] her. She can swim a little, but would rather wade. She has never tangled with a skunk or a porcupine, and she has the good sense to beg a woodchuck's pardon if she trespasses on its property, and go back home. When she dances on her hind legs, down near the brook, it means she has discovered a snake, but she would no more close in on one

than I would wrassle a bear. She has been known to follow a frog or a toad for hours, with the expression of one who does not believe her own nose. The rabbits who share my garden produce found out years ago that they could outrun and outzigzag the poodle, and a red fox who lives nearby once trotted right past her, down the driveway and out onto the road, as big as you please. One night the old dog followed a possum up into the woods and didn't come back for two hours. It was my daughter's opinion that the possum had held the poodle for ransom, but finally decided to let her go. This is calumny of a familiar kind and the poodle is used to it. She is not a hunter or a killer, but an interested observer of the life of the lower animals, of which she does not consider herself one. She regards herself as a member of the human race and, as such, she sees no fun or profit in chasing a ball or a stick and bringing it back, time and again. A hundred terriers have made me miserable since before the First World War by laying a ball at my feet and standing there panting and gasping and drooling until I throw it. Nobody my age can throw a baseball as far as I can, because of these long years of practice. I am told that one short-haired fox terrier, for whom I threw a ball all one afternoon, never did come back when I finally wound up and let go. Goody.

In her old age, the Dowager Duchess of West Cornwall has become a touch imperious and has firmly taken her place as a co-equal in the conduct of certain household affairs, particularly those involving meals. She used to lie obediently in the living-room, with her paws just over the threshold, but if you are a poodle going on seventy-five or a hundred-and-five, you waive, without consultation, the old rules of behaviour. She now removes toast from my grasp if I let my hand fall below what she has established as the point of no return, and now and then she removes from my lap, with a brisk dainty gesture, my napkin, on the ground that the crumbs it has collected belong to her. If you tell her to go in and lie down when you have a dish she especially craves in front of you, she stomps her feet and communicates her flat refusal in a series of guttural sounds very much like an attempt at words. Her range of inflection and intonation, after a decade and a half with people, is remarkable, and I am now able to tell by the quality of her voice, when she is outdoors, who is approaching the house. She not only divides tradespeople into her own classifications, but she has stratified certain friends and acquaintances of ours. Every dog does this, in its minor instinctive way, but without the almost verbal criticism Christabel can bring to her welcome or her inhospitality. She is no longer very hospitable to any caller or visitor, but once a

person gets inside the house, she becomes in a flash the perfect hostess, shaking hands, sniffing pockets or purses to see if they contain chocolates or something dug up out of the ground.

She realized, two or three times as quickly as a member of any other breed could have done it, that I had got so that I couldn't see her, and she gets up quietly when I enter a room where she is lying. Once, when I stumbled into her and fell sprawling, she hurriedly examined me from head to foot, with a show of great anxiety, as if she were looking for compound fractures. Christabel regards me as a comedian of sorts, and always knows when I am trying to be funny for her sake, and always smiles (there is no smile quite like a poodle's), and if the joke is a big production number, such as my opening the door to the downstairs lavatory when she asks to be let out, she gives her guttural laugh, turns her head slowly, and lets my wife in on the gag. Now and then she has disapproved of one of my routines and she makes her disapproval unmistakable.

I slipped out of the house one night when she was upstairs, and began hammering on the door. She charged downstairs, barking with the high indignation she had evinced one day when she came upon three tree surgeons who seemed to her to be taking down the maple trees in front of the house. With my coat over my head, I charged into the house, roaring like the late Wallace Beery. With a new sound I had never heard before, she turned and seemed to slither upstairs on her stomach, but she stopped at the landing, deciding to hold that defence until it became untenable. I started up the stairs in a Lon Chaney crawl, and halfway up she recognized me. She didn't think it was funny and wouldn't shake hands for several days.

She likes to be taken to a country restaurant a few miles from home, where she is petted and fed, and which she apparently thinks I own, since she challenges people who arrive for dinner after she has got there. She doesn't like big parties, unless they are composed only of the half-dozen persons she truly admires, and she goes out into the kitchen until the last car has driven away. Not long ago, at a house where there were many people, and three or four dogs, she became bored when voices were raised in song, and asked someone to let her out. Half an hour

later, the couple that works for us, driving along the road in their car, caught in their headlights a black dog with a yellow collar trotting squarely down the road, and they picked her up. She had come more than a mile from the house of the party she didn't like, and she was on the right road, too, headed for home, but she had a good four miles to go, and that's a long trip for so old a dog. I am confident that she would have got there all right, age or no age.

I said [in a piece I wrote earlier about Christabel] something about burying the old poodle under the apple tree. I take it back. I have no doubt now but that she will see me buried first, but she won't lie on my grave for days and nights on end, if I know Christabel. She will be out in the kitchen, stomping her feet, and trying to talk, and asking for the steak platter. What is more, she will get it, too.

James Thurber
Thurber's Dogs
HAMISH HAMILTON LTD
1955

First Friend

I include this extract by KATHARINE M. ROGERS *because
it seems to me a fine and healthy antidote to the loss of perspective
that too often surrounds our bonds with dogs. Rogers, who is a keen
animal-lover and has also published studies of cats, shows an exemplary
balance in her appreciation of the canine species. Her suggestion that
if we are going to do the best by our dogs, we need to understand and
remember the difference between ourselves and them – which will strike
those who dislike dogs as ridiculous, but is an all-too-common area
of confusion in many households where dogs are kept – is a very
valuable one. Dogs may have gained from their association with us,
but just as often, they suffer from it, usually through no
fault of their own.*

Jon Katz reports in his sociological study *The New Work of Dogs* that people are increasingly relying on dogs to provide the emotional support they cannot get from other people in our disconnected society. His case studies include recently divorced women whose dogs gave them invaluable reassurance and sympathy after their husbands left them and a lonely old man whose dog fulfilled his needs for love and companionship. However, Katz points out, people who rely on their dogs to the point of making them into permanent surrogates for the spouses or children who have failed them are demanding more of the animals than they can possibly give. Dogs are not equipped to provide the complex emotional responses that humans require. Too intense, exclusive intimacy between dog and human (which the dog is helpless to resist) can produce neurotically demanding or badly behaved dogs and disappointed owners. ...

We cannot realistically expect our dogs to pine away after we die or even to dedicate their every thought to us while we live. Reading in Buffon or Taplin that dogs live to please their master, assiduously following every order and anticipating

every wish, makes one wonder whether they ever actually looked at their dogs' behavior. Anyone who observes the dog they live with knows that it has its own priorities and can be deaf to commands that interfere with something it really wants to do. The exalted absolutes of Buffon and the others must have reflected the ideal child or servant they wanted more than the actual sentient animal they had.

Moreover, as Agnes Repplier (a cat enthusiast) astutely pointed out, extravagant exaltation of canine love reflects the author's egotism more than the dog's feeling

Absolute love is only one of the superhuman virtues with which some admirers credit dogs. [Albert Payson] Terhune rhapsodized that they immeasurably excel humans 'in swerveless loyalty, in forgiveness, in foursquare honesty, in humor, in stamina, in adaptability, in conscience, in pluck, in sacrifice.' But dogs' unquestioning fidelity, their eagerness to please superiors and to overlook injuries from them, owe more to the instinctive hierarchical order of the wolf pack than to moral principles; probably they cannot imagine alternative behavior. ... If dogs are not capable of hypocrisy on the human scale, it is because they are unacquainted with human motives for falsification. On their own simpler level, they are quite capable of displaying instant affection to anyone holding a tasty treat.

Dogs are praised for loving without criticism, even though they do so because they are oblivious to human moral distinctions; and yet there is also a persistent myth that there must be some goodness in anyone that a dog loves. ...

In the same way, a person's love for dogs is supposed to be evidence of basic goodness. Although nice people are nice to their dogs and cruelty to dogs surely reveals a nasty nature, it is far from true that kindly feelings toward dogs necessarily reveal anything about the rest of one's character. Adolf Hitler, for example, was very fond of his German shepherds. ...

Surely it is possible to love and appreciate dogs without confusing them with people, or endowing them with superlative virtue or the capacity to perceive or elicit hidden goodness ... we should appreciate dogs for the loving and lovable, sensitive and responsive animals they are. We can recognize that they share many of our needs, perceptions, and feelings without supposing their requirements to be

identical with our own. Attributing to them qualities they do not have reveals a lack of respect for what they are. Ted Patrick points out that those who ascribe mystical, extrasensory powers to dogs are refusing to recognize the reasoning powers that they have. A dog does not 'sense' that its owner is going away; rather, it sees him taking out suitcases and has learned by experience what that means. Considering that dogs have no natural familiarity with vacations and suitcases, that ability to learn is remarkable enough. ...

Our relationships with dogs can be eminently satisfying without being ideal beyond human limits. We can enjoy their love even if we know it is based partly on dependency and is not free of self-interest. Even if we recognize that our dogs love us uncritically because they do not know any better, we all need someone who will greet us enthusiastically whenever we come home, who will never weigh our shortcomings or care about our success in society.

Katharine M. Rogers
First Friend: A History of Dogs and Humans
ST MARTIN'S PRESS
2005

Cornelia

This vivacious account by ELIZABETH VON ARNIM
(1866–1941) will touch a chord with anyone who has ever loved a
dog: the spontaneous and unforced quality of the attachment between
the author and her dachshund is exactly what so many people find
irresistible about canine company. Dachshunds, which are bred in
two different sizes, three coat types and a medley of very pretty colours,
have proved particularly popular pets among artists: the painters
Pierre Bonnard, Pablo Picasso, David Hockney and Andy Warhol
all owned them, and Hockney painted a series of portraits
of his two, Stanley and Boodgie.

Thus did I become engaged, and presently was married and removed to Pomerania; and standing on the steps of the remote and beautiful old house ... in which I was to spend so many happy years, was Cornelia.

We immediately loved. At sight we loved. She too had belonged to that previous wife whose traces were everywhere. My opinion of previous wives, high already because of the ring, leapt to heaven when I saw Cornelia. Far, far better than any ring was that blessed little low-geared dog. She whimpered round me, in delighted recognition that here at last was a playmate and friend.

Her whole body was one great wag of welcome. She showed off. She did all her tricks. She flung herself on her back, so that I might see for myself how beautiful her stomach was—

'Do not,' interrupted my husband, 'kiss the dog. No dog should be kissed. I have provided you, for kissing purposes, with myself.'

Such was the way he talked. Apophthegms. And I used to listen to them with a kind of respectful amusement, my ear cocked, my head on one side. From the very beginning, I enjoyed and treasured his apophthegms.

That first year of marriage, Cornelia and I were everything to each other. Alone all day from directly after breakfast till evening, because my husband went off early to inspect his remoter farms and didn't come back till dark, if I wished to talk I had to talk to Cornelia.

Dogs being great linguists, she quickly picked up English, far more quickly than I picked up German, so we understood each other very well, and *couche*, *schönmachen*, and *pfui* continued for a long time to be my whole vocabulary.

Fortunately, we liked the same things. She only wanted to be out of doors in the sun, and so did I. Expeditions to the nearer woods soon became our daily business, and the instant my husband, in his high cart, had lurched off round the first corner, we were off round the opposite one, disappearing as quickly as we could, almost scuttling, in our eagerness to be gone beyond reach and sight of the servants. ...

I would make for the open; and once in it, once safe, how happy Cornelia and I were! We frisked across the unreproachful fields, laughing and talking – I swear she laughed and talked, – to the cover of the nearest wood. The world was all before us, and my pockets bulged with biscuits and bones which, when sorted out, would be our several luncheons. What could be more perfect? Nothing, out there,

minded what we did. Nothing wanted to be given orders. The March wind, blowing my skirt all anyhow, and causing Cornelia's ears to stream out behind her, didn't care a fig that I was a fleeing *Hausfrau*; the woods, when we got to them – those clear light woods of silver birches, free from obscuring undergrowth, – welcomed us with beauty, just as though I were as deserving as anybody else. Pale beauty it was, in a pale sun; beauty of winter delicately dying, of branches bare, except for mistletoe. But beneath the branches were the first signs of spring, for down among last year's dead leaves, in groups, in patches, in streams, and in some places in lakes, hepaticas were beginning to cover the ground with their heavenly blue.

I would sit in great contentment on a tree-stump, munching my biscuits and staring round at these things, while Cornelia, in great contentment too, but for different reasons, busied herself digging holes and burying her dinner-bones; and I often wondered, I remember, whether any human being could be happier than I was then. Happy indeed, at such moments, seemed my lot. The sun was warm, spring was just round the corner, I had a kind, indulgent husband who was nearly always somewhere else, and there wasn't a soul in sight except a dog.

Elizabeth von Arnim
All the Dogs of My Life
WILLIAM HEINEMANN LTD
1936

Dogs in Art

KENNETH CLARK *(1903–1983) was an internationally
renowned art historian and author, whose television series*
Civilisation *(1969) remains a landmark presentation. This extract
from Lord Clark's book* Animals and Men *(1977) amply demonstrates
not only his profound erudition about art and cultural history, but also
his expert, affectionate understanding and awareness of dogs of all types
(it was clearly a point of pride with him here to identify the white dog that
Gainsborough painted). The subject of dogs in art is an endlessly
fascinating one: the wealth and variety of images and statues
depicting them reveal how intimately and intricately our
lives and theirs have been enmeshed for
thousands of years.*

We know that a medieval gentleman, when he went to bed, had a dog at his feet to keep them warm, and dogs keep that position when their masters have attained the final chill of death. And we know that the Duke of Burgundy, with his usual self-indulgence, had fifteen hundred dogs; and, in the *Très Riches Heures*, two puppies have been allowed on to the banquet table, and are eating out of the plates. In almost the first full-length portrait a small dog occupies the foreground, and Jan Arnolfini's dog introduces us to a new inhabitant of the animal world, the fluffy pet dog, which has continued to share man's affections with the mastiff, or the Great Dane, until the present day. One of them appears, predictably, on one of the unicorn tapestries in Cluny, with the superscription *Mon seul désir*, the most favoured, it would seem, of all the beloved animals in that enchanting series. A fluffy dog has even been allowed into St Augustine's study, where he sits, most unexpectedly, among the armillary spheres and astrolabes, watching the Saint as he sees a vision of St Jerome's death. Who but Carpaccio would have put him there? One could perhaps deduce from Carpaccio's whole approach to life that he loved dogs, and he has left us one of the most completely realized dogs in painting, who sits at the feet of a seated courtesan, in the picture in the Correr that Ruskin praised so extravagantly.

The other predictable dog-lover in Italian art is Paolo Veronese. In at least six of his magnificent compositions, including *The Last Supper*, a dog – usually a large dog – is much in evidence. When Armstead carved his admirable frieze of painters on the podium of the Albert Memorial, Paolo Veronese was the only one to be allowed his dog.

The best-loved dog of the Renaissance is in Piero di Cosimo's picture known as the *Death of Procris*. The dead girl lying on the ground is mourned by two creatures, a faun with goat's legs, half animal, half man, who touches her tenderly, and a dog, who looks at her with a human sorrow and gravity. Of all Renaissance painters the misanthropic Piero di Cosimo seems to have had the greatest sympathy with animals

Jan Arnolfini's decision that his portrait should include his little dog who, unlike his wife, was obviously painted from life, was to appear in many portraits of the next century. I offer as examples Titian's portrait of Clarice Strozzi where ... the little dog shows more animation than the child, and the superb portrait of Giovanni dell' Acquaviva in Kassel. The practice, continued into the next century, produced in the work of Velasquez some of the best portraits of dogs ever executed, the hunting dogs that accompany the Cardinal Infante Don Fernando and Prince Balthasar Carlos. No dog in painting is more confident of being loved than the small, bright companion of the Infante Felipe Prospero. But Velasquez could see further than that. The saturnine animal that sits in front of the dwarfs in *Las Meninas* is not only the greatest dog in art but a somewhat disturbing commentary on the gentle, courtly scene depicted. He seems to echo the contempt of the disdainful dwarf (Maribárbola) behind him. As usual, that inscrutable artist leaves us in doubt about his true meaning. English eighteenth-century portrait painters, no doubt inspired by Titian,
continued the practice of giving their sitters dogs as companions. The most stylish is the foxy white animal in Gainsborough's *Perdita Robinson*. I cannot fit it into any modern classification of dogs – it comes nearest to a White Spitz – but it has an air of breeding and we feel that it could win an award at Crufts. But was it really Perdita's dog? It appears again in Gainsborough's double portrait known as the *Morning Walk*, and is the subject of a picture in

the Tate Gallery that must be one of the earliest portraits of dogs on their own and seems to have belonged to Gainsborough's friend Abel. At any rate, he loved painting it so much that he could not keep it out of his most important commissions. By contrast the dog in Reynolds' *Miss Jane Bowles* really belongs to, and is deeply loved by, its owner. This enchanting picture realizes perfectly the close, warm-hearted relationship between an animal and a child. ...

It is sometimes said that the love of dogs is more intense in England than anywhere else; but this is an illusion. There are many passages in Turgenev's *Sportsman's Sketches* which go at least as far as anything to be found in English literature in their love of dogs and horses. Nevertheless there are countries where, for no clear reason, dogs are despised. In Semitic countries they are considered unclean – 'is thy servant a dog that he should do this thing?' – and the little dog that accompanies Tobias on his journey is a proof that this folk-tale is of Persian origin. In India and most Moslem countries they come in for harsh treatment from simple people who have been told that they are without souls. As the Neapolitan says when reproved for beating his donkey, 'Perche no? Non e christiano.' I have also known some very intelligent Englishmen who rebel against the Anglo-Saxon obsession with dogs. They would be shocked by that remarkably intelligent and unsentimental woman, Edith Wharton. Asked to draw up a list of the seven 'ruling passions' in her life, she put second, after 'Justice and Order', 'Dogs'. 'Books' came third. But in a diary entry she wrote a beautiful modification of her feelings: 'I am secretly afraid of animals – of all animals except dogs, and even of some dogs. I think it is because of the *us-ness* in their eyes, with the underlying *not-usness* which belies it, and is so tragic a reminder of the lost age when we human beings branched off and left them: left them to eternal inarticulateness and slavery. Why? Their eyes seem to ask us.'

Kenneth Clark
Animals and Men
WILLIAM MORROW AND COMPANY
1977

Lost Dog

MICHELLE DE KRETSER *(born c. 1958) is a novelist
who lives in Australia. In this extract from* The Lost Dog *(2008),
she powerfully evokes the web of complex and conflicted feelings we can
experience in our relationships with dogs. Especially poignant are the
man's memories of what he had hoped for from his dog – 'a faithful
presence at his heel', which, had it been achieved, would have prevented
this loss; his sense that not only has the dog not become what
he had hoped, but also he has failed the animal; and, in
the last sentence, the knowledge of what, despite these
failures, the two of them did share.*

At first Tom was not afraid. The dog was given to running off. In parks, beside creeks, over waste ground: tracking a scent, he vanished; emerged as a white band glimpsed among trees or on a plunging hillside; disappeared again. In time – half an hour or so – he would turn up, grinning.

But this was the bush: a site constructed from narratives of disaster. Tom thought of dogs forcing their way into wombat holes, where they stuck fast and starved. He thought of snakes. He thought of sheep, and guns.

There came the sound of barking.

Twenty yards away, a track led up to the ridge. Tom took it at a run, air tearing in his chest. The pale trunks of saplings reeled past.

Away to his right it went on: a high consistent barking designed to attract the pack's attention. So the dog barked when dancing around a tree where a cat or possum clung among leaves. After a while, it would be borne in on him that he was alone in his venture; that the man would not assist in capturing the prey he had gone to the effort of flushing out. Like marriage, their relations had entailed the downward adjustment of expectations. A dog: Tom had pictured a faithful presence at his heel, an obedient head pressed to his knee. And the dog, thought Tom, arms hanging loose, breathing hard on a bush track, what had the dog hoped for from him? Something more than the recurrence of food in a dish, surely; surely some untrammelled dream of loping camaraderie.

Over the years, with patient repetition and bribes of raw flesh, he had taught the dog to fetch. But when he picked up the ball and threw it a second time, Tom would feel the dog's gaze on him. He tried to imagine how his actions might appear from the dog's point of view: the man had thrown the ball away, the dog had obligingly sought out this object the man desired and dropped it at his feet; and behold, the man hurled it away again. How long could this stupidity go on?

'Anthropomorphism,' Karen would have said, his wife being the kind of person who mistrusted emotions that had not been assigned a name. But what was apparent to Tom in all their dealings was the otherness of the dog: the expanse each had to cover to arrive at a corridor of common ground.

Where the bushes fanned less densely, he pushed his way through and found himself on an overgrown path. There was a smell: leafy, aromatic.

The barking now sounded higher up the hill; somewhere to his left, where a wall of grey-green undergrowth barred the way. He pressed on ahead, hoping to loop around behind the dog. His jacket grew damp from the branches that reached across his face. Water found the place between his collar and his skin.

He was so intent on moving forward that at first he didn't notice the silence. When he did, he stopped. Silence meant the dog had given up hope that the pack would come to his assistance; and with it, the chase. Silence meant he was making his way back.

Tom Loxley returned, under a thickening sky, to the place where the wallaby had bounded across the track. Well after the rain came he was still standing there, a slight man in large wet sneakers, calling, calling.

By lunchtime the dog had been gone five hours and the rain over the trees had fined to drizzle. Tom remembered Nelly's raincoat, hanging from a hook behind the bedroom door; it would be too short in the arms, but the hood was the thing. When he took it down, he discovered a promotional calendar from a stock agent stuck to the door. May 2001: no one had torn off a leaf for six months.

The forested crest of the hill was hemmed on the east by the track that ran down from Nelly's house past paddocks and a farmhouse. To the north was the

trail Tom had followed that morning; another led up the hill to the south. Both came out on the ridge road that curved around the top of the hill and turned down into the valley, where it met the muddy farm track. Tom set out along the perimeter of this bush trapezoid, calling and whistling and calling.

He told himself the dog was making the most of freedom, running where his nose led, through the crags and troughs of unimaginable scentscapes.

He reminded himself of the time when two children selling chocolate to raise money for their school left a gate open and the dog escaped into the street. Karen and Tom ran along pavements, checked parks, trespassed, knocked on doors, called animal shelters. Then the phone rang. A woman who lived half a mile away had returned from work to find the dog asleep on her step and her cat's bowl licked clean.

The dog was still hard-muscled, swift and strong. But he was twelve now; old for a dog his size. He spent less time darting after swallows and more snoozing in his basket, dream-paws scrabbling. He would not willingly be out in this rain.

The ridge road was deserted. But it was the route taken by the logging trucks. The drivers, quota-ruled, were always in a hurry. The dog had no traffic sense. With the wind in his face, Tom tried not to think of these things.

He followed a path that led into the bush from the southern track. It took him to a clearing where a treadless tractor tyre held the charred traces of a fire. There were crushed cans; cigarette butts and balled-up tissues disintegrating in the scrub.

The past four days were already assuming the unreal glaze of an idyll: a time of rain broken up by windy sun, the soft, mad chatter of Tom's keyboard, the dog curled like a medallion before the fire.

Michelle de Kretser
The Lost Dog
CHATTO & WINDUS
2008

Disgrace

JOHN MAXWELL COETZEE *(born 1940) is another
Nobel Prize winner, and has also twice won the Booker Prize
with his works of fiction, including the superb and disturbing book
from which this extract is taken,* Disgrace *(1999). The writer was born,
brought up and educated in South Africa, although he is now an
Australian citizen, and his work inevitably has a strongly political
dimension. The stray mongrel dogs described in this desolating extract
carry, within the novel as a whole, a racial significance – freighting
with even more disquiet this account of the way in which
they are systematically destroyed.*

The animals they care for at the clinic are mainly dogs, less frequently cats: for livestock, D Village appears to have its own veterinary lore, its own pharmacopoeia, its own healers. The dogs that are brought in suffer from distempers, from broken limbs, from infected bites, from mange, from neglect, benign or malign, from old age, from malnutrition, from intestinal parasites, but most of all from their own fertility. There are simply too many of them. When people bring a dog in they do not say straight out, 'I have brought you this dog to kill,' but that is what is expected: that they will dispose of it, make it disappear, dispatch it to oblivion. What is being asked for is, in fact, *Lösung* (German always to hand with an appropriately blank abstraction): sublimation, as alcohol is sublimed from water, leaving no residue, no aftertaste.

So on Sunday afternoons the clinic door is closed and locked while he helps Bev Shaw *lösen* the week's superfluous canines. One at a time he fetches them out of the cage at the back and leads or carries them into the theatre. To each, in what

will be its last minutes, Bev gives her full attention, stroking it, talking to it, easing its passage. If, more often than not, the dog fails to be charmed, it is because of his presence: he gives off the wrong smell (*They can smell your thoughts*), the smell of shame. Nevertheless, he is the one who holds the dog still as the needle finds the vein and the drug hits the heart and the legs buckle and the eyes dim.

He had thought he would get used to it. But that is not what happens. The more killings he assists in, the more jittery he gets. One Sunday evening, driving home in Lucy's kombi, he actually has to stop at the roadside to recover himself. Tears flow down his face that he cannot stop; his hands shake.

He does not understand what is happening to him. Until now he had been more or less indifferent to animals. Although in an abstract way he disapproves of cruelty, he cannot tell whether by nature he is cruel or kind. He is simply nothing. He assumes that people from whom cruelty is demanded in the line of duty, people who work in slaughterhouses, for instance, grow carapaces over their souls. Habit hardens: it must be so in most cases, but it does not seem to be so in his. He does not seem to have the gift of hardness.

His whole being is gripped by what happens in the theatre. He is convinced the dogs know their time has come. Despite the silence and the painlessness of the procedure, despite the good thoughts that Bev Shaw thinks and that he tries to think, despite the airtight bags in which they tie the newmade corpses, the dogs in the yard smell what is going on inside. They flatten their ears, they droop their tails, as if they too feel the disgrace of dying; locking their legs, they have to be pulled or pushed or carried over the threshold. On the table some snap wildly left and right, some whine plaintively; none will look straight at the needle in Bev's hand, which they somehow know is going to harm them terribly.

Worst are those that sniff him and try to lick his hand. He has never liked being licked, and his first impulse is to pull away. Why pretend to be a chum when in fact one is a murderer? But then he relents. Why should a creature with the shadow of death upon it feel him flinch away as if its touch were abhorrent? So he lets them lick him, if they want to, just as Bev Shaw strokes them and kisses them if they will let her.

He is not, he hopes, a sentimentalist. He tries not to sentimentalize the animals he kills, or to sentimentalize Bev Shaw. He avoids saying to her, 'I don't know how you do it,' in order not to have to hear her say in return, 'Someone has to do it.' He does not dismiss the possibility that at the deepest level Bev Shaw may be not a liberating angel but a devil, that beneath her show of compassion may hide a heart as leathery as a butcher's. He tries to keep an open mind.

Since Bev Shaw is the one who inflicts the needle, it is he who takes charge of disposing of the remains. The morning after each killing session he drives the loaded kombi to the grounds of Settlers Hospital, to the incinerator, and there consigns the bodies in their black bags to the flames.

It would be simpler to cart the bags to the incinerator immediately after the session and leave them there for the incinerator crew to dispose of. But that would mean leaving them on the dump with the rest of the weekend's scourings: with waste from the hospital wards, carrion scooped up at the roadside, malodorous refuse from the tannery – a mixture both casual and terrible. He is not prepared to inflict such dishonour upon them.

J.M. Coetzee
Disgrace
VINTAGE
2000

Dead 'Wessex' the Dog
to the Household

In this poem, THOMAS HARDY *(1840–1928) evokes the dead spirit of his*
fox terrier, Wessex, which in real life had a fiery temper and was virtually
unmanageable (as indeed are the other fox terriers mentioned
in this book). Wessex is said to have once bitten Hardy's friend
John Galsworthy (see pp. 19–22). But Hardy came to love
the dog, and this poem is a haunting testament
to his attachment.

Do you think of me at all,
Wistful ones?
Do you think of me at all
As if nigh?
Do you think of me at all
At the creep of evenfall,
Or when the sky-birds call
As they fly?

Do you look for me at times,
Wistful ones?
Do you look for me at times,
Strained and still?
Do you look for me at times,
When the hour for walking chimes,
On that grassy path that climbs
Up the hill?

You may hear a jump or trot,
Wistful ones,
You may hear a jump or trot –
Mine, as 'twere –
You may hear a jump or trot
On the stair or path or plot;
But I shall cause it not,
Be not there.

Should you call as when I knew you,
Wistful ones,
Should you call as when I knew you,
Shared your home;
Should you call as when I knew you,
I shall not turn to view you,
I shall not listen to you,
Shall not come.

Thomas Hardy
'Dead "Wessex" the Dog to the Household', from
The Complete Poems of Thomas Hardy
MACMILLAN
1976

Her Dog

TOBIAS WOLFF *(born 1945) is a prize-winning writer.*
His fiction often focuses on the dishonesty in his characters' lives,
and on how much of the truth they can or cannot reveal or face. One
of the most compelling aspects of living with a dog is its silence: the
sense that this highly sensitive and intelligent companion will not pass
judgment on us, but is sympathetic and sees far more than it can ever tell.
In this gentle but moving story, Wolff uses an imagined dialogue between
the dog and its owner to explore the feelings that the man has buried.
Through the dog's spontaneous 'outbursts' – 'I miss her! I miss
her!' – the man is able finally to admit his own grief
about his wife's death.

When Grace first got Victor, she and John walked him on the beach most Sundays. Then a Chow-Chow bit some kid and the parks department restricted dogs to the slough behind the dunes. Grace took Victor there for years, and after she died John stepped in and maintained the custom, though he hated it back there. The mushy trail hedged with poison oak. Baking flats of cracked mud broken by patches of scrub. The dunes stifled the sea breeze, leaving the air still and rank and seething with insects.

But Victor came alive here in spite of himself. At home he slept and grieved, yet grief could not deaden the scent of fallow deer and porcupine, of rabbits and rats and the little gray foxes that ate them. Dogs were supposed to be kept on the leash for the sake of the wildlife, but Grace had always left Victor free to follow his nose, and John couldn't bring himself to rein him in now. Anyway, Victor was too creaky and cloudy-eyed to chase anything; if he did catch some movement in the brush he'd lean forward and maybe, just to keep his dignity, raise a paw – *Eh? That's right, run along there!* – and then go back to smelling things. John didn't hurry him. He lingered, waving away the mosquitoes and flies that swarmed around his head, until the hint of some new fragrance pulled Victor farther along the trail.

Victor was drawn to the obvious delights – putrefying carcasses, the regurgitations of hawks and owls – but he could just as easily get worked up over a clump of shrubbery that seemed no different than the one beside it. He had his nose stuck deep in swamp grass one damp morning when John saw a dog emerge from the low-hanging mist farther up the trail. It was a barrel-chested dog with a short brindled coat and a blunt pink snout, twice Victor's size, as big as a lab but of no breed familiar to John. When it caught sight of Victor it stopped for a moment, then advanced on stiffened legs.

'Scram!' John said, and clapped his hands.

Victor looked up from the grass. As the dog drew near he took a step in its direction, head craned forward, blinking like a mole. *Huh? Huh? Who's there? Somebody there?*

John took him by the collar. 'Beat it!' he said. 'Go away.'

The dog kept coming.

'Go!' John shouted again. But the dog came on, slowly now, almost mincing, with an unblinking intentness. It kept its yellow eyes on Victor and ignored John altogether. John stepped in front of Victor, to break the dog's gaze and force himself on its attention, but instead it left the trail and began to circle around him, eyes still fixed on Victor. John moved to stay between them. He put his free hand out, palm facing the dog. Victor gave a grumble and strained forward against his collar. The dog came closer. Too close, too intent, it seemed to be gathering itself. John reached down and scooped Victor up and turned his back on the dog. He rarely had occasion to lift Victor and was always surprised at his lightness. Victor lay still for a moment, then began struggling as the dog moved around to face them. 'Go away, damn you,' John said.

'Bella! Whoa, Bella.' A man's voice: sharp, nasal. John looked up the trail and saw him coming, shaved head, wraparound sunglasses, bare arms sticking out of a leather vest. He was taking his sweet time. The dog kept circling John. Victor complained and squirmed impatiently. *Put me down, put me down.*

'Get that dog away from us,' John said.

'Bella? He won't hurt you.'

'If he touches my dog I'll kill him.'

'Whoa, Bella.' The man sauntered up behind the dog and took a leash from his back pocket. He reached for the dog but it dodged him and cut back in front of John, keeping Victor in view. 'Shame, Bella! Shame on you. Come back here – right now!' The man put his hands on his hips and stared at the dog. His arms were thick and covered with tattoos, and more tattoos rose up his neck like vines. His chest was bare and pale under the open vest. Beads of sweat glistened on the top of his head.

'Get control of that dog,' John said. He turned again, Victor still fidgeting in his arms, the dog following.

'He just wants to make friends,' the man said. He waited until the dog's orbit brought him closer, then made a lunge and caught him by the collar. 'Bad Bella!' he said, snapping on the leash. 'You just have to be everybody's friend, don't you?'

John set Victor down and leashed him and walked him farther up the trail. His hands were shaking. 'That dog is a menace,' he said. '*Bella*. Jesus.'

'It means "handsome".'

'No, actually, it means "pretty". Like a girl.'

The man looked at John through his bubbly black shades. How did he see anything? It was irritating, like the display of his uselessly muscled, illustrated arms. 'I thought it meant "handsome",' he said.

'Well it doesn't. The ending is feminine.'

'What are you, a teacher or something?'

The dog suddenly lunged against its leash.

'We're going,' John said. 'Keep your dog away from us.'

'So, are you a teacher?'

'No,' John lied. 'I'm a lawyer.'

'You shouldn't have said that about killing Bella. I could sue you, right?'

'Not really, no.'

'Okay, but still, you didn't have to get all belligerent. Do you have a card? This friend of mine had his film script totally ripped off by Steven Spielberg.'

'I don't do that kind of law.'

'You should talk to him. Like, D-day? You know, all those guys on the beach? Exactly the way my friend described it. *Exactly*.'

'D-day happened,' John said. 'Your friend didn't make it up.'

'Okay, sure. But still.'

'Anyway, that movie was years ago.'

'So you're saying statute of limitations?'

The opening notes of 'Ode to Joy' shrilled out. 'Hang on,' the man told him. He took a cell phone from his pocket and said, 'Hey, lemme call you back, I'm in kind of a legal conference here.'

'No!' John said. 'No, you can talk. Just please keep Bella on the leash, okay?'

The man gave the thumbs-up and John led Victor away, up into the mist the other two had come out of. Right away his skin felt clammy. The bugs were loud around his ears. He was still shaking.

Victor stopped to squeeze out a few turds, then looked up at John. *My savior. I guess I should be panting with gratitude. Licking your hand.*

No need.

How'd you put it? I'll kill him if he touches my dog. What devotion! Almost canine. Victor finished and made a show of kicking back some dirt. He raised his head and tested the air like a connoisseur before starting up the trail, feathery tail aloft. *I could've handled him.*

Maybe so.

He wasn't going to do anything. Anyway, since when do you care? It's not like you even wanted me. If it hadn't been for Grace, those guys at the pound would've killed me.

It wasn't you I didn't want – you in particular. I just wasn't ready for a dog.

I guess not. The way you carried on when Grace brought me home. What a brat.

I know.

All your little conditions for keeping me. I was her dog. All the feeding, all the walking, picking up poop, baths, trips to the vet, arrangements with the kennel when you went out of town – her responsibility.

I know.

Her *dog,* her *job to keep me out of the living room, out of the study, off the couch, off the bed, off the Persian rug. No barking, even when someone came right past the house – right up to the door!*

I know, I know.

And when they kicked me off the beach, remember that? No way you were going to get stuck back here. No, Grace had to walk me in the swamp while you walked along the ocean. I hope you enjoyed it.

I didn't. I felt mean and foolish.

But you made your point! Her dog, her responsibility. You let her walk me in the rain once when she had a cold.

She insisted.

Then you should've insisted more.

Yes. That's what I think, too, now.

I miss her! I miss her! I miss my Grace!

So do I.

Not like me. Did I ever bark at her?

No.

You did.

And she barked back. We disagreed sometimes. All couples do.

Not Grace and Victor. Grace and Victor never disagreed. Did I ignore her?

No.

You ignored her. She would call your name and you would go on reading your paper, or watching TV, and pretend you hadn't heard. Did she ever have to call my name twice? No! Once and I'd be there, looking up at her, ready for anything. Did I ever want another mistress?

No.

You did. You looked at them in the park, on the beach, in other cars as we drove around.

Men do that. It didn't mean I wanted anyone but Grace.

Yes, you did.

Maybe for an hour. For a night. No longer.

Then I loved her more than you. I loved her with all my heart.

You had no choice. You can't be selfish. But we men – it's a wonder we forget ourselves long enough to buy a birthday card. As for love ... we *can* love, but we're always forgetting.

I didn't forget, not once.

That's true. But then you missed out on being forgiven. You never knew how it feels to be welcomed home after you've wandered off. Without forgiveness we're lost. Can't do it for ourselves. Can't take ourselves back in.

I never wandered off.

No. You're a good dog. You always were.

Victor left the trail to inspect a heap of dirt thrown up by some tunneling creature. He yanked at the leash in his excitement. John unclipped him and waited as Victor circled the mound, sniffing busily, then stuck his nose in the burrow and began to dig around it. To watch him in his forgetfulness of everything else was John's pleasure, and this is where he found it, Sundays in the bog with Victor. He looked up through a haze of insects. A buzzard was making lazy circles high overhead, riding the sea breeze John could not feel down here, though he could faintly make out the sounds it carried from beyond the dunes, of crying gulls and crashing waves and the shrieking children who fled before them. Victor panted madly, hearing none of this. He worked fast for an old fellow, legs a blur, pawing back clumps of black earth. He lifted his dirty face from the hole to give a hunter's yelp, then plunged back in.

<div align="center">

Tobias Wolff
'Her Dog', from *Our Story Begins*
BLOOMSBURY
2008

</div>

For a Good Dog

OGDEN NASH (1902–1971) *wrote quirky, ingenious*
verse about a myriad of creatures: eels, octopuses, pigs, panthers,
grasshoppers, calves, hippopotamuses, ants, porpoises, sharks, centipedes,
wasps, flies and termites are just some of his subjects. And dogs. Nash is
sometimes credited with coining the phrase 'A dog is man's best friend',
and he wrote, among other poems, 'Love Me But Leave My Dog Alone'
and 'Two Dogs Have I', managing even to find a rhyme for 'schnauzer'
('he fondled schnauzers/With no scathe to his trousers'). The delightful
poem reprinted here celebrates the little dog's youth and tenderly
evokes her decline into old age, affirming, all the while, the way
in which owner's and dog's lives mirror each other.

My little dog ten years ago
Was arrogant and spry,
Her backbone was a bended bow
For arrows in her eye.
Her step was proud, her bark was loud,
Her nose was in the sky,
But she was ten years younger then,
And so, by God, was I.

Small birds on stilts along the beach
Rose up with piping cry,
And as they flashed beyond her reach
I thought to see her fly.
If natural law refused her wings,
That law she would defy,
For she could hear unheard-of things,
And so, at times, could I.

Ten years ago she split the air
To seize what she could spy;
Tonight she bumps against a chair,
Betrayed by milky eye.
She seems to pant, Time up, time up!
My little dog must die,
And lie in dust with Hector's pup;
So, presently, must I.

Ogden Nash
'For a Good Dog', from *Collected Verse From 1929 On*
J.M. DENT & SONS LTD
1961

Timbuktu

In his fiction, American author PAUL AUSTER *(born 1947)*
has repeatedly examined the themes of language and of dispossession.
In Timbuktu *(1999), the novella from which this extract is taken, these*
fuse in the character of Mr Bones, a dog that lives on the streets with its
homeless owner. Auster is reported to have said, 'There is no more honest
or sympathetic witness than a dog', and the story, told from the dog's
point of view, enables Auster to examine aspects of American society and
human behaviour through an unflinchingly honest, if often baffled, eye.
A deeply moving undercurrent to the book is the dog's tenacious
longing to be reunited with its master in the afterlife.

That was where people went after they died. Once your soul had been separated from your body, your body was buried in the ground and your soul lit out for the next world. Willy had been harping on this subject for the past several weeks, and by now there was no doubt in the dog's mind that the next world was a real place. It was called Timbuktu, and from everything Mr Bones could gather, it was located in the middle of a desert somewhere, far from New York or Baltimore, far from Poland or any other city they had visited in the course of their travels. At one point, Willy described it as 'an oasis of spirits'. At another point he said: 'Where the map of this world ends, that's where the map of Timbuktu begins.' In order to get there, you apparently had to walk across an immense kingdom of sand and heat, a realm of eternal nothingness. It struck Mr Bones as a most difficult and unpleasant journey, but Willy assured him that it wasn't, that it took no more than a blink of an eye to cover the whole distance. And once you were there, he said, once you had crossed the boundaries of that refuge, you no longer had to worry about eating food or sleeping at night or emptying your bladder. You were at one with the universe, a speck of anti-matter lodged in the brain of God. Mr Bones had trouble imagining what life would

be like in such a place, but Willy talked about it with such longing, with such pangs of tenderness reverberating in his voice, that the dog eventually gave up his qualms. *Tim-buk-tu.* By now, even the sound of the word was enough to make him happy. The blunt combination of vowels and consonants rarely failed to stir him in the deepest parts of his soul, and whenever those three syllables came rolling off his master's tongue, a wave of blissful well-being would wash through the entire length of his body – as if the word alone were a promise, a guarantee of better days ahead.

It didn't matter how hot it was there. It didn't matter that there was nothing to eat or drink or smell. If that's where Willy was going, that's where he wanted to go too. When the moment came for him to part company with this world, it seemed only right that he should be allowed to dwell in the hereafter with the same person he had loved in the herebefore. Wild beasts no doubt had their own Timbuktu, giant forests in which they were free to roam without threat from two-legged hunters and trappers, but lions and tigers were different from dogs, and it made no sense to throw the tamed and untamed together in the afterlife. The strong would devour the weak, and in no time flat every dog in the place would be dead, dispatched to yet another afterlife, a beyond beyond the beyond, and what would be the point of arranging things like that? If there was any justice in the world, if the dog god had any influence on what happened to his creatures, then man's best friend would stay by the side of man after said man and said best friend had both kicked the bucket. More than that, in Timbuktu dogs would be able to speak man's language and converse with him as an equal. That was what logic dictated, but who knew if justice or logic had any more impact on the next world than they did on this one? Willy had somehow forgotten to mention the matter, and because Mr Bones's name had not come up once, *not once* in all their conversations about Timbuktu, the dog was still in the dark as to where he was headed after his own demise. What if Timbuktu turned out to be one of those places with fancy carpets and expensive antiques? What if no pets were allowed?

Paul Auster
Timbuktu
FABER AND FABER
1999

INDEX